LUXOR MUSEUM
THE GLORY OF ANCIENT THEBES

Text by Abeer el-Shahawy
Photographs by Farid Atiya

LUXOR MUSEUM

The Glory of Ancient Thebes

Text by Abeer el-Shahawy
Photographs by Farid Atiya

Published by Farid Atiya Press
© Farid Atiya Press

P.O. Box 75, 6th of October City, Giza, Cairo, Egypt
www.faridatiyapress.net

First edition, 2005

Third printing, 2010

No part of this book may be reprinted, or reproduced nor utilized in any form or by any electronic, mechanical or other means now known or hereafter invented, including photocopying and recording, or any information storage and retrieval systems, without written permission from the author.

Colour Separation by Farid Atiya Press

Printed and bound in Egypt by Farid Atiya Press

Dar el-Kuteb Registration 13262/2005

ISBN 977-17-2352-9

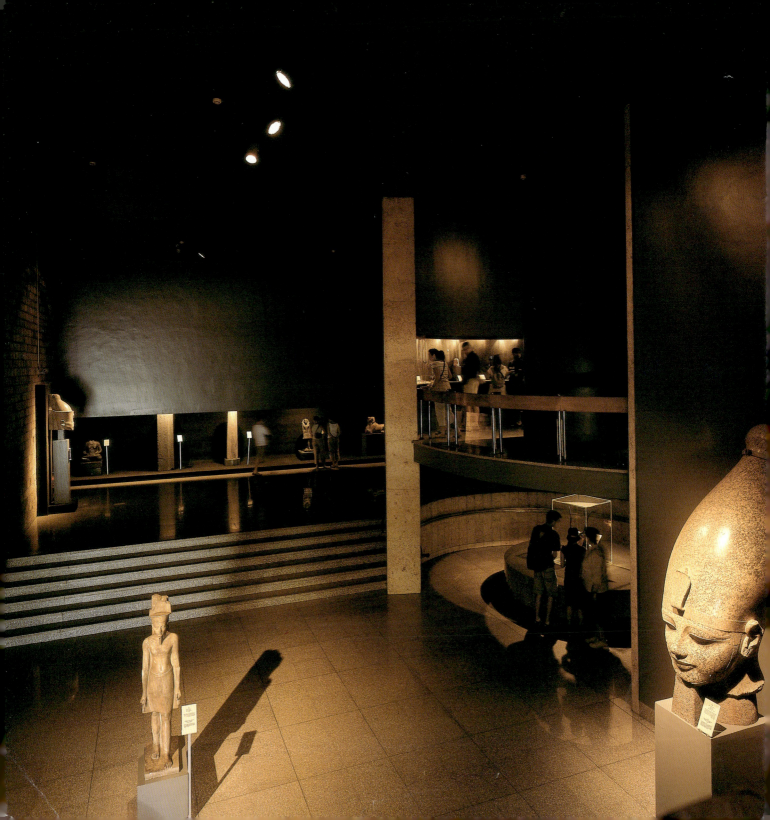

CONTENTS

Preface	9
Introduction	11
The Plates	33
Statue of King Amenhotep III, represented on a sledge.	34
Statue of goddess Iwnet	38
Statue of goddess Hathor	42
Statue of Horemheb before Amen	44
Statue of Horemheb and god Atum	46
Statue of the cobra god Amen Kamutef	48
Colossal head of Amenhotep III	50
Tutankhamen as god Amen	52
Head of Senusert III	54
Statue of Amenemhat III	58
Relief of the god Amen	62
Standing statue of Tuthmosis III	64
Tuthmosis III wearing the *atef* crown	68
Statue of the crocodile god Sobek	70
God Sobek with Amenhotep III	72
Stela of Pia	76
God Amen and his wife the goddess Mut	78
Seated Statue of Tuthmosis III	80
Victory stela of Kamose	84
Mummy of King Ahmose	86
King Amenhotep II as an archer	88
Statue of King Amenhotep II	90
Statue of Ramsses II	92
King Seti I	96
Statue of Neb-Re	98
Statue of King Ramsses VI	100
Statue of a prisoner	102
The lioness goddess Sekhmet	104
Amenhotep, son of Hapu	106
Relief of a victory parade.	108
King Ramsses III	110
Block statue of Yamunedjeh	112
A nobleman wearing the 'gold of honour'	114
Hatshepsut represented as a woman in the presence of Amen	116
Head of King Amenhotep I	120
Head of Akhenaten	122
Wall decoration from Akhenaten's *Gem pa Aten* temple	124
Bust of Akhenaten	128
Senusert I as Osiris	130
Top of a niche	132
Male figure on a bed	134
Glossary of Ancient Egyptian words	136
Index	137
Bibliography	140

Entrance

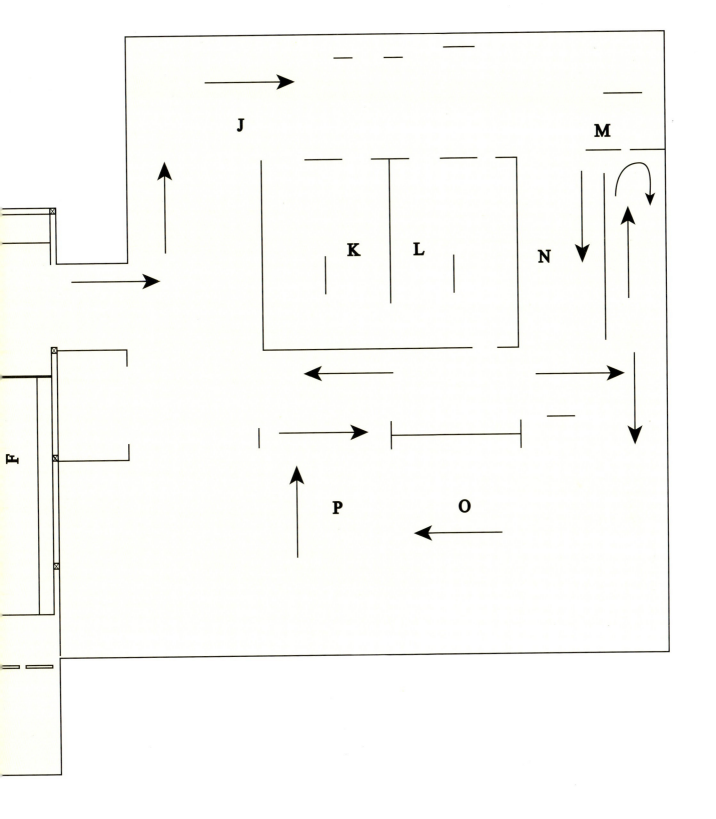

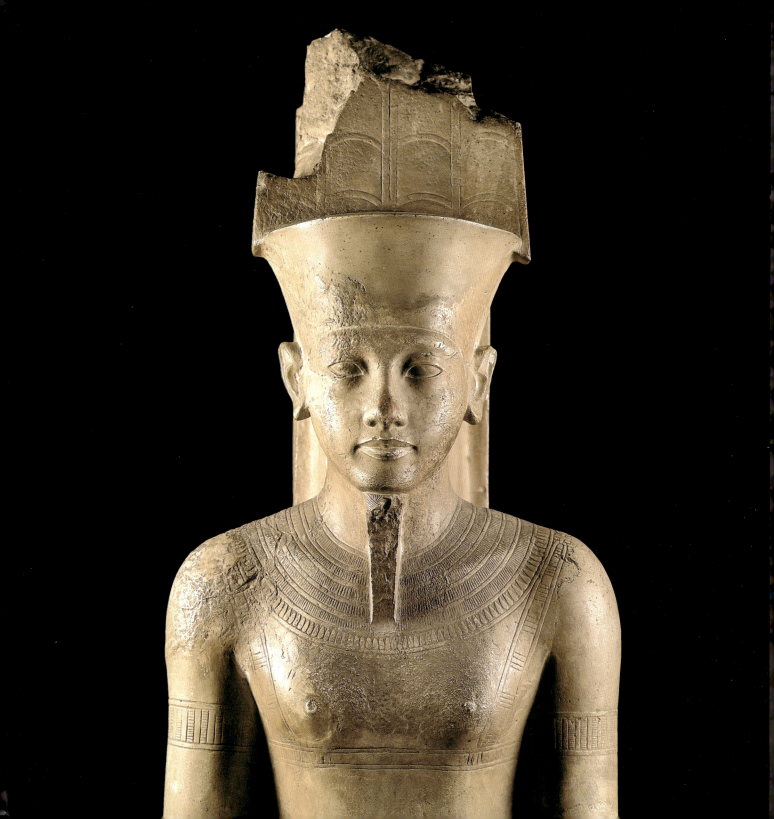

PREFACE

Being an Egyptologist, over the years I have had the opportunity to make many trips and visit wonderful ancient sites all over Egypt, but it is at Thebes that I have always felt the most overwhelmed by the sheer grandeur of the antiquities it contains, and the magnitude of the epochs it encompasses. That is why I chose the ancient capital to be the subject of my Masters Thesis, which was completed in 2004, titled "A study of the Funeral Procession Scenes in the New Kingdom Nobles' Tombs in Thebes". Walking through the temple halls, climbing the mountains to visit the many tombs is like taking part in an investigation through the archives of its ancient history, as one reaches back to the distance past. In fact, the number of Theban monuments is sufficiently large and varied enough to introduce the visitor to its days of glory, when Thebes was the political and religious capital of the Egyptian empire. The statues and artefacts housed in the Luxor Museum are souvenirs of the splendour that was Thebes. They reflect the glory of the great pharaohs and their times, of the wealthy noblemen and the skilled and meticulous artists. Each statue has a special meaning and recalls a particular aspect of this ancient heritage. They reveal historical details, not only about their patrons, but also about the social, economic and political climate of the ancient city, silently attesting to the splendour of the past.

Each piece is a reminder of a particular event, a certain location; a specific phase and period in the history of the city. One can imagine Thebes, the city of a hundred gates with its vast temples, luxurious palaces, magnificent pharaohs and exquisite queens, as well as the rich and powerful priests. Akhenaton, the philosopher king, is there, and so is Tutankhamen with his gorgeously wrought treasures of gold, and Ramsses II with his chariots, battling for the empire, and erecting his colossal statues. Overlooking this pageant was the awesome necropolis on the west bank of the Nile, guarding its many legacies and secrets.

The artefacts appearing in this book were carefully chosen and photographed so at to reveal all their fine workmanship and intrinsic beauty. They were selected either for their historical importance or their artistic merit, and are arranged in the exact order of a museum visit taken by the visitor. The book aims, through detailed descriptions and comprehensive explanations, to identify the place and role played by each of the pieces in the history of Thebes.

Abeer el-Shahawy

Left : *Tutankhamen as the god Amen, see page 52.*

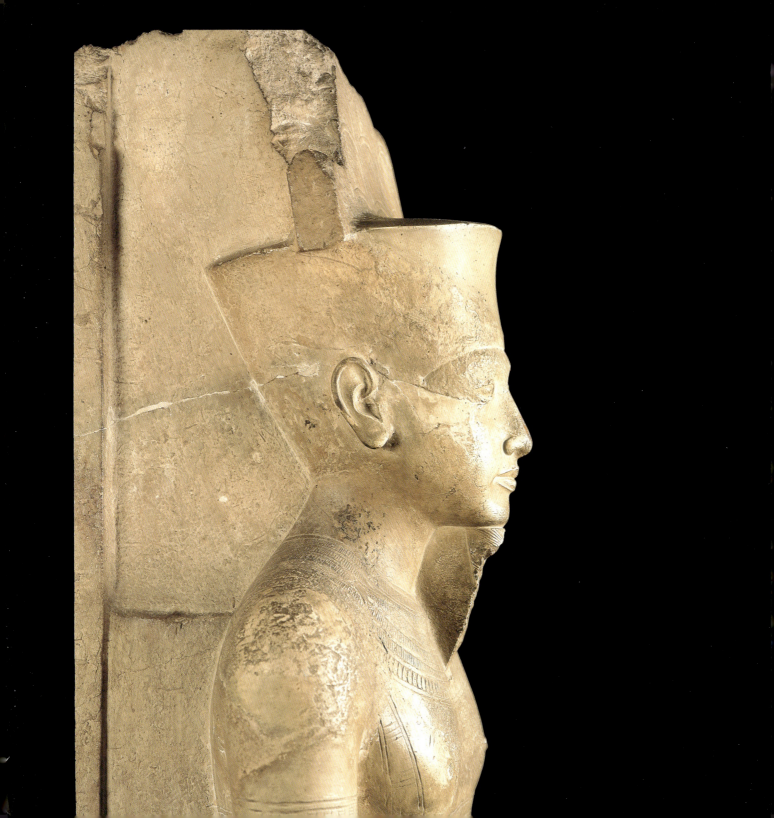

INTRODUCTION

On either side of the Nile, four hundred and four miles due south of Cairo, lies the magnificent city that witnessed the full glory of the Egyptian civilization. A great metropolis, which was a religious and political capital of Egypt, and a great centre of power and luxury, never before witnessed. Its name in the ancient Egyptian language was waset, meaning 'the sceptre of authority'. Luxor its present name is derived from the Arabic al *Kusur*, meaning palaces. During the Greco-Roman period it was called Thebes, which was derived from the ancient Egyptian word *ta ipet,* meaning 'the sacred'. Thus the glorious city that houses a third of the antiquities of the whole world has had three names over the millennia. During most of its ancient history, the city always enjoyed a special prestige and played an important role in national events.

The city today, which lies on both banks of the Nile, preserves within its heart a great heritage and a remarkable legacy.

On the east side of the river, are the temples of Karnak and Luxor connected to each other via an avenue lined with sphinxes. Both temples were dedicated to the great god Amen, the principal protector of the empire and the other two members of the Theban triad: his wife Mut and their son the moon god Khonsw. Building at Karnak, which took its name from a nearby village, started early in the 12th Dynasty and it continued to be a religious centre for many centuries after that. In its heyday the temple of Amen was called 'the most privileged of places', *ipt swt,* and today it still contains within its precincts, a matchless record of ancient Egyptian art and history.

On the west side of the Nile in the Theban necropolis, lie the tombs of hundreds of royals, nobles and artisans, in addition to several mortuary and funerary temples designated 'the house of millions of years', in the hope that it would last forever.

Left : *Tutankhamen as the god Amen, see page 52.*

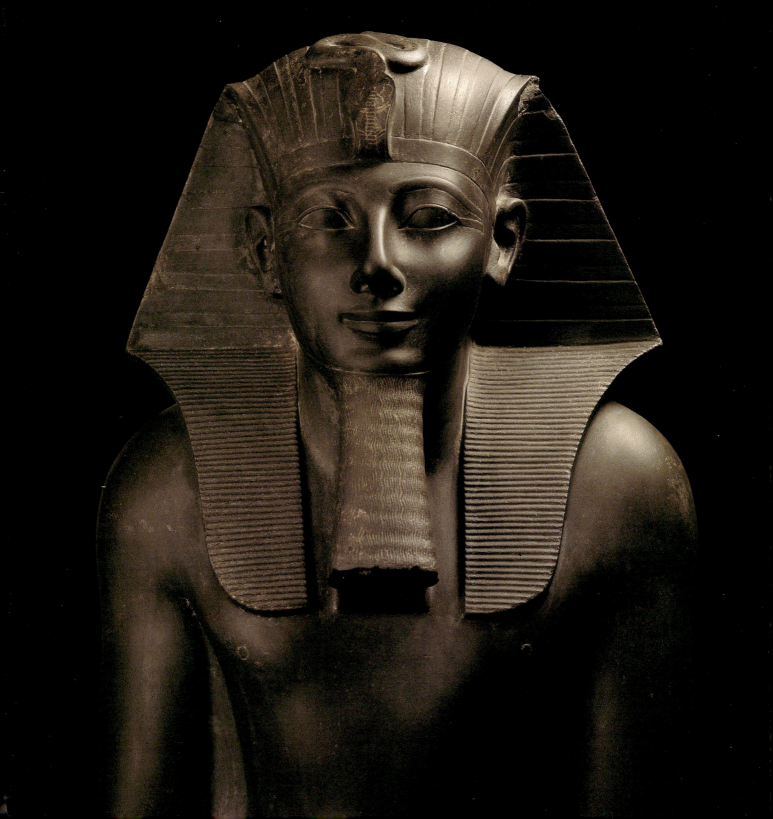

The Valley of the Kings was the burial site of the ancient pharaohs of the New Kingdom, as well as for a small number of noblemen, priests and other royal family members.

The Valley of the Kings takes its name from the Arabic description of the place as *Wadi Biban el Melouk*, meaning 'valley of the gates of the kings'. In ancient times it was called 'the great noble necropolis of millions of years of the pharaoh'. It is a valley that was eroded out of the surrounding mountains millions of years ago by rainfall. The site was probably chosen as a place for royal burials due to the high quality of its limestone, and also because a nearby peak was shaped like a pyramid, which was associated with the solar cult.

The Valley of the Queens was called *Bibaan el Harim* or *Bibaan el Malikaat* by the Arabs, and was referred to as 'the great valley' by the ancients. It was used for the burials of high officials during the middle part of the 18th Dynasty; while in the 19th Dynasty, many queens and sons of the kings were buried there. Accordingly it was described by the ancients as 'the place of the beauties' and 'the great place of the royal children, wives and mothers'.

The tombs of the nobles extend for two miles along the foothills of the Western Desert, about three miles distance from the river. The presence of a centralized government in Thebes induced the grandees to build their tombs there. Later on these were lived in and suffered much damage and abuse over many centuries. The dryness of the desert air helped to preserve them, but man only added to their decay. Some of the richly detailed scenes of funerary processions were cut from the walls to be sold; while others were defaced for religious or superstitious reasons.

Most of the tombs were oriented from east to west, as the tomb entrance led the deceased symbolically from the east to the beautiful west.

The nobles' tombs along the western slopes of these parts of the necropolis are facing the Nile, running from north to south:

Dra Abu El Naga, named after a Moslem saint to whom a small mosque is dedicated; it extends for about one mile to the south of the road leading to the Valley of the Kings.

Assasif, is a name related to a Coptic rite in which palm leaves are waved, or it might relate to interconnecting underground passages. More likely, the term is the plural of al Assaf, which is a personal name and thus refers to a tribe of this name who resided there in more recent times. It runs westward to Deir el Bahri.

Al-Khokha (the peach), lies south of Assasif.

Sheikh Abd el-Qurna, named after the domed tomb of another local saint, has the largest concentration of ancient nobles' tombs. It lies to the west of the Ramesseum and

Left : *Statue of Tuthmosis III, see page 64.*

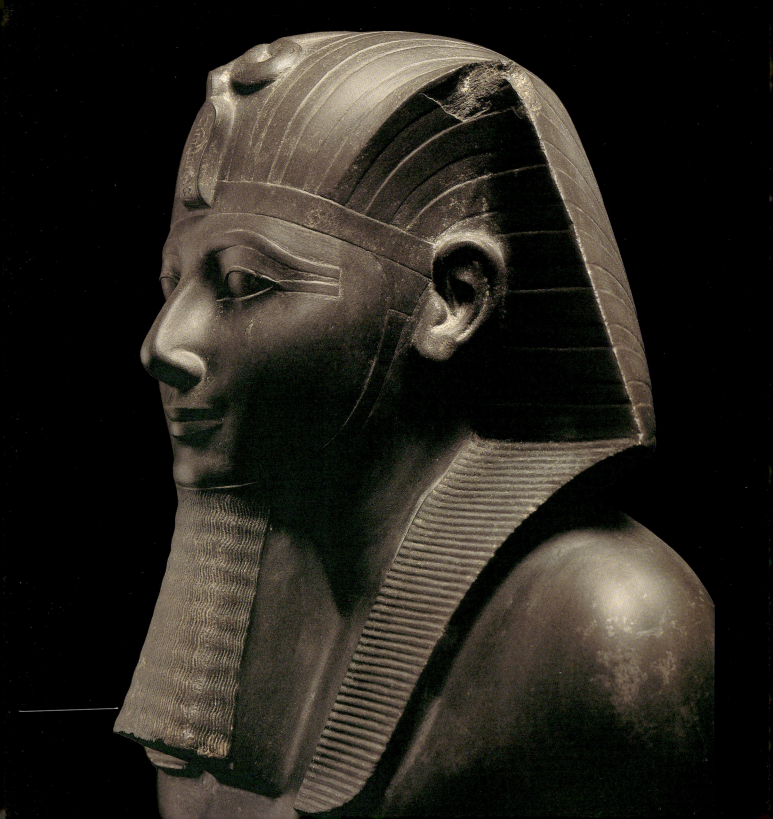

to the south of Deir el Bahri, at the base of the Qurna hills. The rock is of a high quality suitable for reliefs, while that higher up is more friable so better suited to paintings.

Qurnet Mouraii, also named for a local saint buried there, lies north of Medinet Habu and to the east of Deir al Medina.

Another interesting site in the Theban Necropolis is Deir el Madina; the modern name refers to the necropolis housing the village and tombs of the artisans, who constructed and decorated the royal tombs in the Valleys of the Kings and the Queens. It was founded in the early part of the 18th Dynasty and was inhabited till the end of the 20th Dynasty. During the Late Period it was used as a cemetery and in Ptolemaic times a temple to the goddess Hathor was erected there. Later a Coptic monastery was built within the Ptolemaic temple enclosure, giving it the name 'the monastery of the town'.

During the Pre-Dynastic and Archaic Periods, the time of the 1st and 2nd Dynasties (3050-2687 BC), Thebes was a relatively modest town in the Upper Egyptian nome. Menes, the unifier of Egypt and the founder of the 1st Dynasty, established Memphis as the capital of the united country. Thebes was the capital of the 4th ancient Egyptian nome during the period covering the 3rd to 6th Dynasties of the Old Kingdom (2687-2191 BC). In a sculpture of a triad, which includes Mecyrinus, the builder of the third pyramid at Giza, the king is shown standing between the goddess Hathor and the personification of that nome called Waset. This figure was represented as a short man, bearing on his head the three emblems of the nome: the djed, symbol of stability, the was, of prosperity and the ankh, of life. The text below him mentions 'the offering of all the good things of the south to the king, who will shine as king of Upper and Lower Egypt for evermore'.

The goddess of the city was Waset, while there was also Montu, the god of Armant, which was around seven and a half miles south of Luxor. The god Amen at that early stage of civilization was a local deity, a member of the Ogdood or the group consisting of the eight gods who were worshipped in El Ashmuneen near Minya in Middle Egypt.

Private tombs of high officials and nomarchs dating to the Old Kingdom were discovered in two areas of the Theban necropolis at the sites of el Tarif and el Khokha. Some were mud brick *mastabas*, while others were hewn from the Theban Mountains like (TT 186), (TT 405) and (TT 413) in El Khokha. Some burials also dating to this period were simple shaft tombs located in the area of Draa Abul Naga.

After the fall of the pharaohs of the Old Kingdom, an interim ineffective phase known as the First Intermediate Period (2190-2061 BC) succeeded it. This era covering the 7th to 10th Dynasties lasted almost two centuries, and was a time of decentralization during which law-making and the social structure of the country fell apart. This in turn led to changes in certain political, social and even religious traditions.

Left : *Statue of Tuthmosis III, see page 64.*

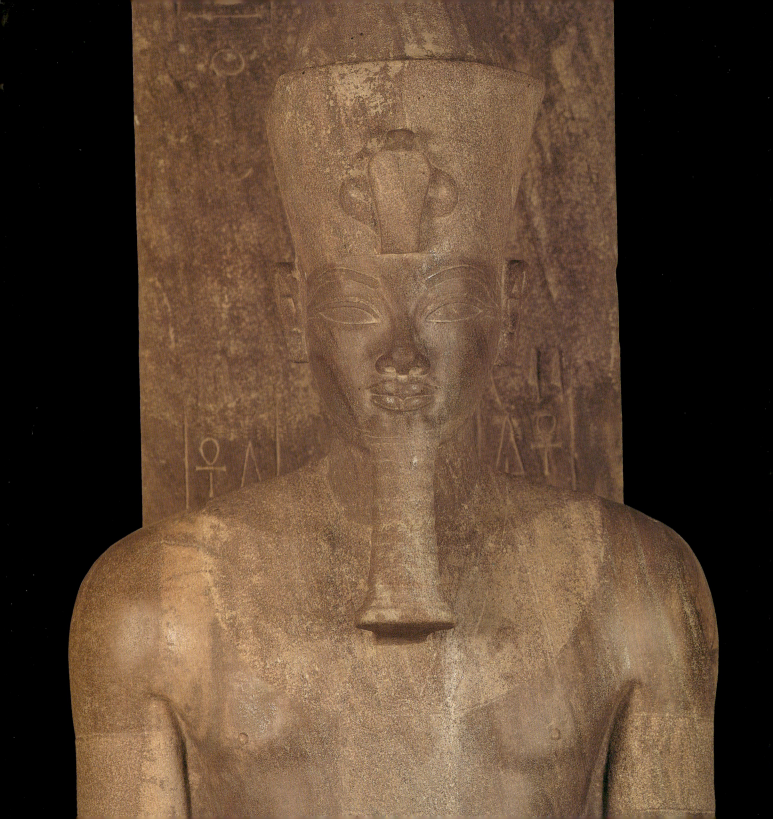

Nothing is known about the short-lived 7th Dynasty apart from the legend that seventy kings ruled in as many days, which while probably an exaggeration certainly indicates that there was severe unrest. The 8th Dynasty included one hundred and eighty kings who ruled from Memphis. Two ruling houses emerged during the 9th and 10th Dynasties; one based in the north at Ahnasia near Beni Suef, and the other controlling seven southern provinces from a base at Coptos near Thebes. Shortly after this phase, the leadership of the south fell into the hands of a powerful Theban family, the Intefs, who would eventually reunite Egypt.

There was great competition between the two ruling houses of Upper and Lower Egypt to win control of the country. This resulted in periodic eruptions of armed conflict, which continued throughout the hundred years of the 9th and 10th Dynasties.

The first three kings of the early 11th Dynasty were called Intef I, II and III, and they all constructed large tomb complexes in the area of el Tarif in Thebes. Those tombs are referred to as *saff* tombs. (*Saff* meant rows, indicating the row of columns in front of those tombs.) Other nobles and high officials erected their private saff tombs near the royal complexes.

The leader of the struggle for the reunification of Egypt was Montuhotep Nebhepetre, a member of the ruling house of Thebes. Montuhotep eventually succeeded in gaining the upper hand over the northern Ihnasian family and ascended the throne of a unified Egypt, thus founding the Middle Kingdom. He commemorated his victory by building a chapel to Hathor at Dendara, 45 miles north of Luxor (Thebes), and a temple to the war god Montu at al-Tud, south of Luxor. He erected his tomb and mortuary temple in the area of Deir al Bahri in Luxor. Nobles and high officials also built their tombs on the slopes overlooking the royal tomb and temple. A notable example is that of Meketre (TT 280), famous for the stupendous collection of wooden models it contained.

The 12th Dynasty was a prosperous period for Egypt. Its founder, Amenemhet I Sehetepibre, who ruled from 1991 to 1962 BC, asserted that he had been chosen by the will of the gods to be king. He claimed that an old prophecy from the reign of Sneferu, founder of the 4th Dynasty, had foretold his ascendance to the throne. He began his reign in Thebes, paying great respect to the god, Amen, but some years later he moved his capital to al-Lisht, eighteen miles south of Saqqara. He named the new city *Ithet-tawi*, or 'the seizer of the two lands'. By this means he wished to demonstrate his power by establishing his own capital in a new territory, an area blessed moreover with abundant natural resources, notably the fertile soil and plentiful water of Fayoum. Its location had strategic advantages too, being more or less at the centre of the country. Thebes, however, did not

Left : *Statue of Amenhotep III, see page 34.*

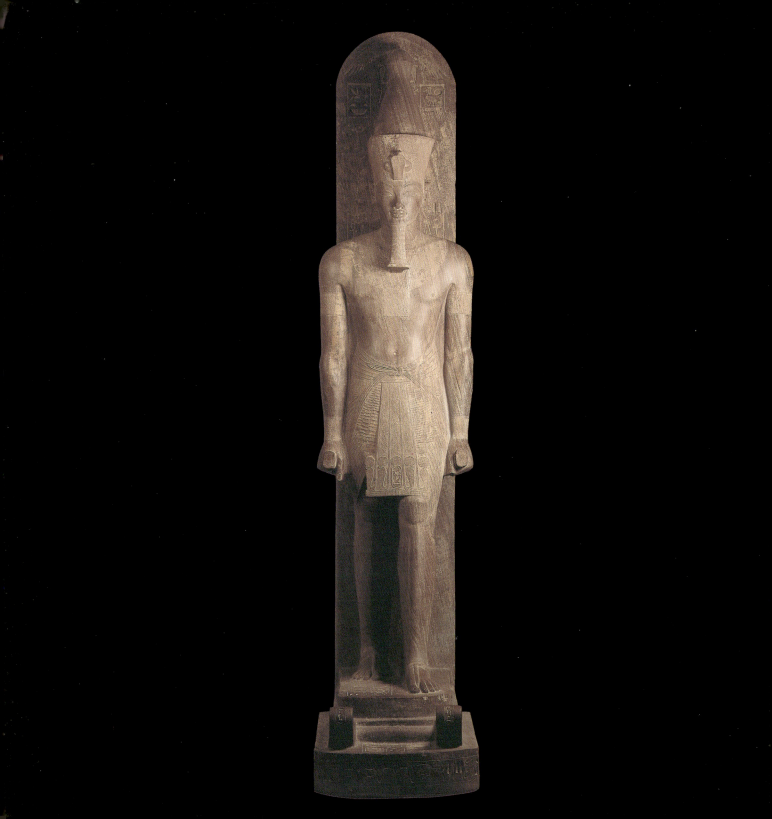

lose its importance. The tomb of the Vizier Intefiker (TT 60) in El Qurna shows the glory that was Thebes in the 12th Dynasty.

His son Senusert I and his successors, although they lived in al-Lisht also paid great respect to Thebes and its god Amen.

After the fall from power of the 12th Dynasty; another of obscure origins the 13th Dynasty took over the throne, with some of its kings ruling from Thebes and others from *Ithet-tawi*. The southern borders were maintained as far as the Second Cataract. However a more turbulent period was to come; the country's unity was weakened and fragmented; the Egyptian historian Manetho, (circa 300 BC), mentions that Egypt was invaded from the east towards the end of this dynasty.

These newcomers were the Hyksos, the so-called 'shepherd kings', who razed the cities, plundered the country and usurped the throne. Their name *hekaw khaswt*, indicated 'the rulers of the highlands'; and they were mentioned as early as the 12th Dynasty in the story of Sinuhe. It is believed they originated from Asia, infiltrating in small groups through Palestine and the eastern Delta, and acquired authority after the fall of the Middle Kingdom. Their weaponry—large shields and composite bows—gave them confidence and a great advantage in battle, making them much feared by the Egyptians. Above all they were helped by their chariots drawn by war horses from the steppes, a method of warfare that they introduced into the country.

The Hyksos did not rule a unified country however; rather their system of governance comprised a grouping of a number of tribes. In addition to the Hyksos pharaohs, another the 14th Dynasty, appears to have established itself in the western Delta, probably contemporaneous with the 15th Dynasty. While it is extremely difficult to ascertain the exact dates and dynasties of the period, some scholars consider it likely that the rulers of the 14th Dynasty were resisting the Hyksos kings, while the 15th and 16th Dynasties were associated with them, and the 17th Dynasty with the rulers in Thebes.

The Hyksos controlled Memphis and the eastern Delta, building their capital at *Ht-waret* (Avaris), now called Tel al-Dabaa, near Zagazig. This was not far from the ancient route linking Egypt to Palestine. They fortified their new capital with huge fortresses, where they stationed large numbers of troops, and built a temple to honour and worship the god Seth. Their rule lasted for 108 years, during which time they became assimilated enough to take theophoric (divinely inspired) names, and represented themselves wearing traditional royal dress. However they had little impact on artistic trends in sculpture and painting, nor on traditions, religion or language. On the contrary, they did their best to identify themselves fully with the Egyptian people and clearly thought the country was theirs, and they fully intended to stay.

Left : *Statue of Amenhotep III, see page 34.*

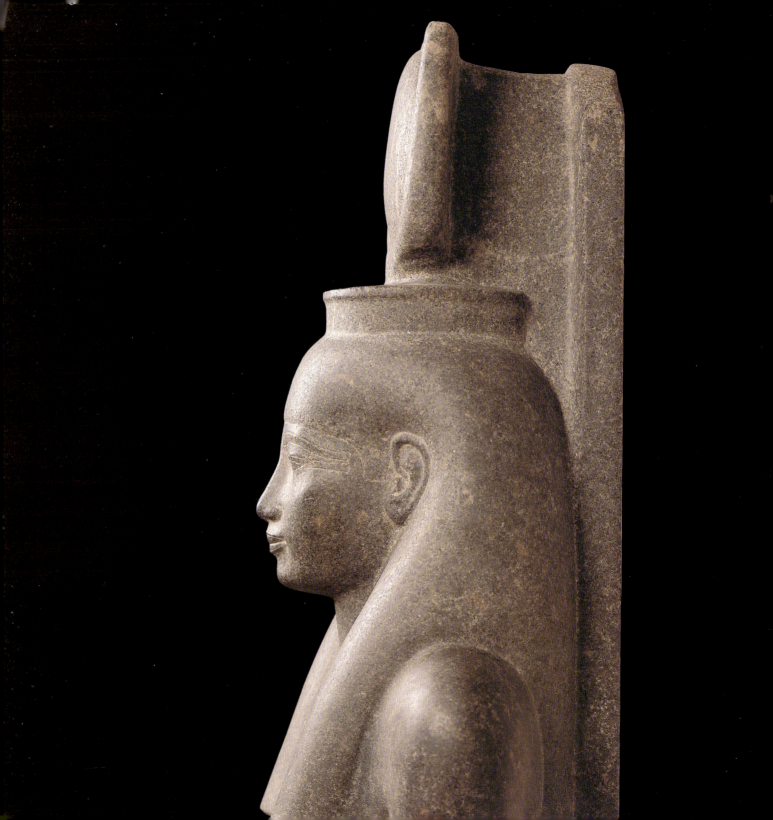

The New Kingdom, the third glorious period in the history of ancient Egypt, lasted from the sixteenth to the eleventh centuries BC and included the 18th to the 20th Dynasties. This was a whole new empire in which the expression *usekh n tashw*, meaning 'expanding Egypt's borders' first appeared in the phraseology of its rulers.

The founder of the 18th Dynasty was Ahmose I Nebpehtire, who after the disruption caused by the Hyksos occupation, united Egypt into one nation again.

During the Second Intermediate Period control of Egypt had been divided between the Hyksos in the north, whose rule extended as far as Abydos, and the Thebans, who had authority over the southern half of the country. The Theban ruling house was identified as the 17th Dynasty and was contemporaneous with the 16th Dynasty of the Hyksos. Sekenenra Taa II (1600 to 1571 BC), one of the last rulers of the 17th Dynasty, took secret measures to consolidate his army in preparation for a war of liberation to expel the Hyksos. The Hyksos King Apophis, who ruled from Avaris in the north, meanwhile, provoked Sekenenre by sending him a messenger to tell him that the noise made by the hippopotami in Thebes bothered him in Avaris to such an extent that it deprived him of sleep. The message was written in narrative style: "Let there be a withdrawal of the hippopotamus from the canal, which lies on the east of the city, because they do not let sleep come to me neither in the daytime nor the night for the noise of them is in the ears of my citizens". Apophis probably meant to show Sekenere that he was aware of the military preparations in the south, and was making a counter-threat.

It seems to have been Sekenenre who began the struggle to liberate the country; as examination of his mummy revealed five deep wounds to his head, which indicated he was killed on one of the military campaigns he waged against the Hyksos. He was succeeded by his son Kamose (1571-1569 BC), who also continued the struggle against the Hyksos occupation.

During this part of the Theban history, the area of Draa Abu el Nagga in the northern part of the Theban necropolis was probably the main Theban cemetery for royal burials.

Kamose was succeeded by his brother Ahmose (1569-1545 BC), who was destined to be the liberator of Egypt by delivering the country from the Hyksos domination. Ahmose was the last ruler of the 17th and the founder of the 18th Dynasty; he marked the end of one era and the beginning of a new one, regaining the prestige of the royal house and its position as an esteemed and sacred image. Thebes remained the capital of the unified country, and now acquired greater importance.

Thebes was the cult centre of the great deity Amen, the divine god who had helped Egypt and its sovereigns to endure and solve the crisis of the Hyksos occupation. The

Left : *Statue of goddess Hathor, see page 42*.

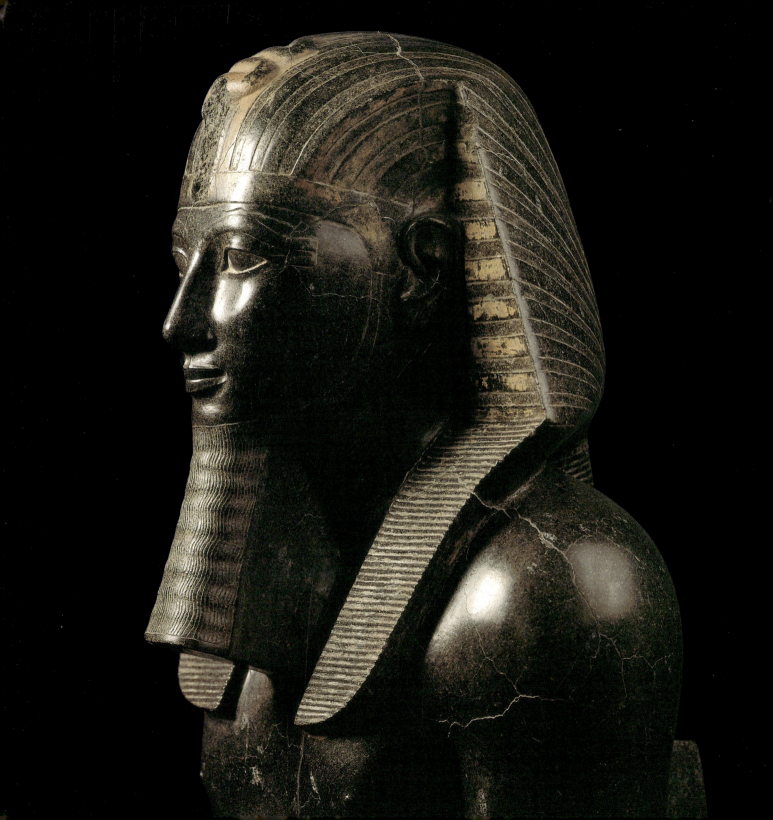

rulers of Thebes fought under the banner of Amen and dedicated their victories to him, a tradition that was maintained throughout the duration of the New Kingdom.

The priests of the god Amen at the cult centres in Karnak and Luxor temples became extremely important figures in society; the temples enjoyed great economic advantages, being endowed with wealth and great estates. In Thebes, the vizier was the next in command after the sovereign, while a second vizier was sometimes appointed in Memphis. Some viziers were also high priests of Amen. The vizier supervised the *nomarchs* (provisional governors) and held firm control over the provinces.

Ahmose I was succeeded in around 1545 BC by his son Amenhotep I, during whose reign cultural life and sciences flourished. This is attested to by the Ebers Papyrus composed at that time, which contains a list of medical diagnoses and prescriptions for the ailments.

Amenhotep I died in 1525 BC and was succeeded by his son Tuthmosis I. He ruled for only nine years, but his reign was notable for three military expeditions in Nubia and northeast Palestine. In contemporary records, he described these campaigns as a great delight to his soul, because he was consolidating his country. He extended the southern boundary of the empire to the Fourth Cataract in Kush, where he appointed a native ruler who was given the title *sa nswt in kash*, 'son of the king in Kush'. He extended his north eastern operations to the neighbouring countries of Western Asia to check the advance of the Mittani (Northern Syria and Northern Iraq), and secure the borders and trade routes. On reaching Naharina in Iraq, he crossed the Euphrates river and laid a stela marking his new border on its eastern bank. He described this river as having a reverse current, with the water flowing south contrary to the Nile whose waters ran north. Tuthmosis enjoyed great success in his campaigns, and found much pleasure in hunting wild animals, especially elephants. He was proud of what he had achieved for Egypt as well as the state of security and prosperity he had maintained in the country. His building operations were remarkable; he added two pylons to the Karnak temple, where he also erected two obelisks. He was the first king known to be buried in the Valley of the Kings, where Ineni, his architect, described his tomb as a secret, sacred place: 'no one seeing, no one hearing'.

The crown prince Amenmese, an army commander, predeceased his father and the throne passed to his brother Tuthmosis II Akheperenre (1516 to 1504 BC). Tuthmosis II was not the son of the 'Great Royal Wife', but of a secondary wife named Mutnefret; he married his half-sister Hatshepsut Maetkare and they had one child, the princess Nefrure. Apart from an expedition to Nubia to suppress a minor uprising, his reign was peaceful and uneventful. Following the premature death of Tuthmosis II, his son by a minor wife,

Left: *Statue of Tuthmosis III, see page 80.*

Tuthmosis III Menkheperre, inherited the throne. Since he was still a child, his stepmother Hatchepsut became his co-regent and the country's *de facto* ruler.

Seven years later Hatshepsut appointed herself the sole sovereign and adopted the royal titles. She sat on the throne of Egypt for twenty-one years during a reign, which stands out for the high quality of its art and architecture. Hatshepsut sent military campaigns to secure the borders in Nubia to the south, and in Syria and Palestine. She also undertook great building operations and the restoration of temples nationwide. As well as her temple in Deir al-Bahri, she had a temple cut out of the rock in the vicinity of Beni Hassan called by the Greeks Speos Artemidos (Grotto of Artemis), thought to be the first such temple in ancient Egypt.

After her death Tuthmosis III, who had been kept very much in her shadow, became the sole sovereign of Egypt. He dated this first year as the twenty-first year of his reign, as he considered himself to have been the legitimate king throughout Hatshepsut's reign.

Tuthmosis III now came into his own, making a name for himself as a great warrior king. He led seventeen military campaigns in Syria-Palestine, where several towns and rebellious principalities had formed an alliance against Egypt under the leadership of the prince of Kadesh, a city on the river Orontes, southwest of Homs in Syria, together with Tunip on the Lower Orontes and the Mittani beyond the Euphrates. Tuthmosis III led his first campaign and reached Megiddo in northern Palestine, which controlled the major trade route between Asia and Egypt. His military tactics proved his iron nature and excellent strategic ability. He defeated the prince of Megiddo, shattered his forces and captured his strongholds.

Tuthmosis went on to lead several campaigns in Syria-Palestine. In the thirty-third year of his reign after defeating the king of the Mittani he crossed the Euphrates and set up a boundary stela to mark the northern limits of his empire. In a campaign in the year forty-two, he won a victory and subdued Kadesh and Tunip. In addition, his southern campaigns in Nubia, secured the country's border at the Fourth Cataract.

Egypt was showered with booty and tribute from Nubia and Western Asia, which increased the wealth of the country. Tuthmosis used this abundance of resources to undertake massive building operations of his own, while not neglecting the great monuments of his predecessors. In the temple at Karnak he listed sixty-one of his distinguished forefathers to whom he made offerings, also honouring them in their own temples. Two ancestors he particularly admired were Senusert III and Thutmosis I, who had so distinguished themselves by their military actions in securing the country and its borders.

Tuthmosis III died in the fifty-third year of his reign (1504 to 1452 BC) and was succeeded by his son Amenhotep II (1454 to 1419 BC). At this time Thebes was the hub of political power and economic wealth, as well as being the centre of the expanding cult of

Amen. Meanwhile Memphis continued as the northern seat and was an important strategic military base, while Iwn (Heliopolis), was an important centre of theology.

Amenhotep II was succeeded by his son Tuthmosis IV Menkheperure, who inherited a rich and powerful country extending from Nubia in the south to Syria in the north. Throne rivalries may have accompanied his accession as he wrote a fictitious story of the event on a stela and placed it between the paws of the Great Sphinx at Giza, to verify his legitimate claim to the throne. On it Tuthmosis stated that as he lay sleeping in the shadow of the Sphinx after a day's hunting, the god Heremakhet appeared to him in a dream in the form of the Sphinx and promised that if he would clear away the accumulation of sand around his body, he would grant him the throne of Egypt.

The reign of Tuthmosis IV (1419-1410 BC) was marked by less manifestations of Egyptian military achievements or power, as peace prevailed throughout the empire. Tuthmosis IV married the daughter of Artatama, the ruler of the Mittani, as a way to guarantee continued peace and diplomatic accord. This princess became one of his main queens, while the Western Asiatic princesses his father Amenhotep II and grandfather Tuthmosis III had married, were considered only minor wives.

One of these wives, Mutemwia, was the mother of his son and heir Amenhotep III Nebmaetre (1410-1372 BC). During the reign of that great king, Egypt reached its highest apogee of wealth and luxury. Rich resources flooded into the country with income from taxes, tributes, commercial relations, trade, quarrying and mining. Artistic and cultural interactions with Western Asia increased.

Amenhotep III was succeeded by his son and heir Amenhotep IV, who also inherited a strong and stable empire that stretched for two thousand miles from north to south. His relatively brief reign—he ruled from 1372 to 1355 BC—was unique in the history of ancient Egypt. Remarkably, he overturned the traditional religious concepts and introduced an entirely new idea—monotheism. Perhaps not surprisingly this unorthodox theory was not well received, and after a brief flowering was not seen again in Egypt for fifteen hundred years, until Christianity made its tentative beginnings into the region.

This short-lived but extraordinary era instituted by Amenhotep IV, known as the Amarna Period, brought dramatic changes not only in religion but in art and social philosophy. Yet although innovative artistic themes were introduced, the deep-rooted traditional canons and compositions were never entirely abandoned.

One of Amenhotep's first steps was to change his name to Akhenaten Neferkheperure-waenre, which meant 'the devoted to the Aten, beautiful is the form of Ra, the sole one of Ra'. Akhenaten could mean the 'illuminated manifestation of the Aten' or 'the one who is effective to the Aten'. The changes Akhenaten initiated concerned the nature of the deity. This change was fundamental. From the dawn of

civilisation Egyptians, in common with other ancient peoples, had been polytheistic, believing in a number of gods each bearing a relation to an abstract or a physical quality or entity. Akhenaten did away with all this. He proposed that the only god was the sun god, the Aten, a revolutionary doctrine, which is regarded as monotheistic and as such ahead of its time. But it proved to be fatally flawed in its attempt to rewrite the beliefs of millennia, as it did not make allowances for the firmly held beliefs of the Egyptian people.

The new, pivotal worship of the Aten developed out of the worship of the traditional sun gods. Akhenaten announced that the Aten was the sole creator. Solar religion was by no means new in Egypt, and even the god Amen was associated with Ra, god of the sun; however the emphasis in the case of the Aten was in regard to his nature as a life giving light force as manifested by the sun's rays. Akhenaten prohibited the old cult of Amen and eliminated its powerful priesthood, dealing a further blow with the closure of Amen's temple at Gebel Berkel near the Fourth Cataract.

Egypt also had a new capital. The centre of administration shifted from Thebes northwards, down the Nile to Akhet Aten, 'the horizon of the Aten', today called Tel al-Amarna located near Minya. The modern day name was taken from a tribe known as Beni Omran, who lived in the area. AkhetAten was not just a new capital but was also the centre of the new religion. The city stretched for some six miles along the east side of the Nile, and here Akhenaten lived with his wife Nefertiti—the epitome of classical beauty and one who enjoyed exceptional power as a queen consort—and their six daughters,

Akhenaten not only ordered changes in the culture, art, religion, iconography and architecture of the country, but he also modified the language. He introduced linguistic changes and used less formal patterns to complement his elaborate plan of emphasising his divinity and demonstrating his uniqueness by means of a distinct literary style. These changes influenced Egyptian culture for generations.

Akhenaten had another, minor wife named Kiya, who was described as the *hemet mrrty aat,* 'the greatly beloved wife', who may have predeceased him. Kiya's eldest son was Semenekhkare, who probably ruled for three years after the death of his father. Semenekhkare was the brother of the next king, Tutankhamen, who was a nine year old boy at the time of his ascension to the throne.

In 1346 BC this young king died after ruling for only ten years and was buried with elaborate ceremony. His tomb was left undisturbed until 1922 when it was discovered by Howard Carter on a mission sponsored by Lord Carnarvon. Tutankhamun's tomb is the most complete evidence yet of the extravagance of the royal burials.

Ay Kheperkheperure, whose name meant 'the forms of Ra exist', married the widow of the King *Twt ankh Amen*, Queen Ankes en pa Amen, and ruled for three years (1346-1343 BC). He had been a prominent nobleman during the reign of Akhenaten, and

is believed to have been a kinsman or even the father of Nefertiti. He acquired titles such as 'overseer of all his majesty's horses', 'the royal scribe' and 'the fan bearer on the right of the king'. Under Tutankhamun, he was given the principal priestly title of 'the god's father', and played a key role in the restoration of the old cult of Amen and the other deities in Thebes and the rest of the country. On the death of Tutankhamen, Ay was represented as performing the funerary rite of the Opening of the Mouth for the dead king, and was an influential supporter of the royal family.

Upon Ay's death an army general, Horemheb, ascended the throne.

Horemheb (1343 to 1315 BC) issued a series of decrees known as the rules and laws of Horemheb, declaring his intention to restore order and to put a stop to injustices resulting from the actions of high officials. Thus he put into place measures to protect taxpayers and working class people from the domination of corrupt employees, and conducted a firm policy within the army, announcing his intolerance of disorder. He also engaged in building activities, adding the second, ninth and tenth pylons in the temple at Karnak, incorporating the stones from the dismantled Talaatat, Akhenaten's temple to the Aten, in his constructions.

Horemheb nominated Ramsses I as his crown prince. Ramsses I Menpehtire (1315 to 1314 BC), whose name meant 'born by Ra, the endurance of the power of Ra', was the founder of the 19th Dynasty. He had been a vizier and a high official, and was the son of an army officer called Seti from Avaris, the city of the god Seth and the former Hyksos capital in the eastern Delta.

The period of the 19th and 20th Dynasties is referred to as the Ramesside Period, since many of the sovereigns of the two dynasties bore this name. Ramsses I ruled for less than two years and was succeeded by his son Seti I. Ramsses I was also buried in the Valley of the Kings.

Seti I's reign (1314 to 1304 BC) was described as *wehem msw*, meaning 'the renaissance'. He wanted to regain the power and prestige Egypt had enjoyed under Tuthmosis IV and Amenhotep III, and launched three military campaigns in Palestine-Syria, recovering Amurru and Kadesh, although these would be lost again the following year. In the third year of his reign he foiled an attack from Libya on the north western border. He also launched a massive building programme; he began the construction of the first hypostyle hall at Karnak and built a funerary temple at Qurna on the west bank at Thebes. In addition he built a vast temple at Abydos dedicated to Osiris, together with the Osireion a symbolic cenotaph for the cult of Osiris, with himself likened to the god. His tomb (KV17) is the longest and most beautiful tomb in the Valley of the Kings.

Seti I was succeeded by his son Ramsses II (1304-1237 BC), a brave fighter and a great builder of monuments; a man of peace and champion in war. He built a new capital

Pr Ramessu in the eastern Delta near modern Qantir, thirty miles from Zagazig and twenty from Tanis. His rock-cut temples in Nubia include Beit al-Wali, Derr and two at Abu Simbel; his partially rock-cut temples are Gerf Hussein and Wadi al-Seboua. As well as these, he built a chain of fortresses along the Libyan coastal route. Fine statues were produced during his reign, although they could be said to have been almost mass-produced being very alike in appearance.

Ramsses II's most famous battle was that of Kadesh against the Hittites, in the fifth year of his reign. Troubles rumbled on with the Hittites until his twenty-first regnal year, when he signed a peace treaty. His reign was a cosmopolitan period. Foreigners moved into Egypt in large numbers and occupied various jobs at all social levels.

Ramsses outlived three crown princes and was succeeded by his thirteenth son, Merenptah (1237 to 1226 BC). He was an active warrior king, crushing an attack launched by the Libyans—who had allied themselves with the Proto-Hellenic 'sea people' in his fifth regnal year. His viceroy meanwhile managed to overcome a threat from the Nubians in the south

Merenptah was succeeded by Amenmes, who was probably a son of a secondary queen. His reign lasted for only three years, after which the throne passed to Seti II. His reign was also short, (1221 to 1215 BC), but during this time he completed the triple roomed chapel for the sacred barque of Amen in the great open court at Karnak, and his own tomb in the Valley of the Kings (KV 15). He was succeeded by his son Siptah who died while still young. For the next two years Egypt was ruled by another queen, Tawosret, who had been the consort of Seti II. The 19th Dynasty drew to a close in civil conflict, with the high administrators fighting over the throne.

The struggle was won by Sethnakhte, who during his brief reign (1200 to 1198 BC) managed to bring an unsettled decade to an end and founded the 20th Dynasty. He was an elderly man, but when he died after only two years, he was succeeded by his son Ramsses III, the dynasty's greatest figure, whose rule lasted from 1198 to 1166 BC.

Ramsses III was an active builder and a great warrior. He repelled two attacks from Libya in the fifth and eleventh years of his reign, and in the eighth year he defeated the 'sea people', who had migrated from the Aegean Sea and brought down the Hittite rulers.

Towards the end of his reign there was a conspiracy in the royal *harim* over the succession. When Ramsses III died, the sons and grandsons who ruled after him were all called Ramsses; from Ramsses IV to Ramsses XI. Down to the last sovereign of the 20th Dynasty, they were less able and powerful. National insecurity prevailed, with the Libyans repeating their raids on the Nile Valley. Egypt's empire fell apart; it lost its territories in Western Asia and Nubia, together with the tribute it had received from them and access to

their gold mines. This resulted in the impoverishment of the country and a weakness in the economy that led in turn to lawlessness, which included stealing the rich items buried inside private and royal tombs and temples.

The first of the line of kings responsible for this disintegration was Ramsses IV (1166 to 1160 BC), who began his reign in good faith by adding the finishing touches to the temple of Khonsu at Karnak, initiated by his father. He began building his tomb in the Valley of the Kings (KV 2), the plan of which survives on a papyrus in the Turin Museum. For materials he sent quarrying expeditions to Wadi Hammamat and to Sinai.

Ramsses IV was succeeded by his son Ramsses V, who ruled for only three years, before himself being succeeded by his uncle Ramsses VI (1156 to 1149 BC). The famous Wilbur Papyrus, which is 11 yards long and dates from his reign, has contributed much to our knowledge of agriculture in ancient Egypt.

He was succeeded by his son Ramsses VII (1149 to 1141 BC), whose tomb is in the Valley of the Kings (KV 1). Since he outlived his son and heir he was succeeded by his uncle Ramsses VIII, another son of Ramsses III, who reigned for only three years and left no tomb. The next in line to the throne was his nephew Ramsses IX.

During the eighteen-year rule of Ramsses IX insecurity increased, with raids from across the desert by marauding Libyans forcing people on the west bank to take refuge within the fortress walls of the mortuary temple of Ramsses III (Medinet Habu). The economic downturn led to inflation in grain prices in Thebes, which caused great unrest. In the thirteenth year of his reign a gang led by an artisan began systematically robbing the tombs of the nobles, and within a short time had violated the tomb of one of the kings of the 17th Dynasty. A year later another band from the artisans' village at what is now Deir al-Medina, robbed the tomb of Isis, queen consort of Ramsses III, of its valuables. Tomb robberies continued throughout the reigns of the next two kings.

Ramsses IX was buried in the Valley of the Kings (KV 19) and was succeeded by his son Ramsses X, who probably ruled for only nine years and whose tomb (KV 52) was never finished. He was followed by his son Ramsses XI (1111 to 1081 BC), who ruled for Thirty years. In the ninth year of his reign a scandal erupted concerning a robbery at the Ramesseum, the funerary temple of Ramsses II, where a large amount of gold and other treasure was kept. Priests and temple officials from the temple of Ramsses III (Medinet Habu) were accused of the theft. The scale and manner of the incident drew attention to the loss in law and order to the extent that Ramsses recalled his viceroy in Kush, Panehsy, to Thebes and commissioned him to impose martial law.

In Ramsses XI's eighteenth regnal year, Panehsy clashed with Amenhotep, high priest of Amen, who had had a relief carved of himself at Karnak, which was as large as the king's thus breaking with the tradition of showing the king as the highest figure

among the nobles. Confronted by Panehsy, Amenhotep fled to the north where his adversary followed him with an army; but the latter then retreated back to Nubia. The army he left behind caused havoc, looting and destroying towns. This is the event described as 'the year of the hyenas … when one was hungry'.

The following year Ramsses XI left Pr Ramessu, the Delta capital, and travelled south to Thebes to restore peace and announce the onset of a new era of authority, order and justice. It was to be a *wehem mswt*, 'a renaissance'. His dream of greatness, however, was short-lived: he was overshadowed by the powerful men he appointed to achieve that very revival. He himself took up residence in Memphis, and appointed Herihor as viceroy in Nubia and governor of Upper Egypt, also making him a high priest of Amen. In the north, the king appointed Semendes as governor of Lower Egypt.

Herihor oversaw the capture and trials of the tomb robbers and ordered the reburial of Ramsses II and Seti I, whose tombs had been looted. He made additions to the temple at Karnak; augmented the decorations of the temple at Khonsu, where he assumed the royal titles and had his name inscribed in a cartouche. He sent the priest Wenamun to Byblos on the Phoenician coast to obtain precious wood to build a new barque for Amen, but Wenamun was maltreated in Byblos and registered that fact in a story that illustrates the serious loss of Egyptian prestige in the region. This story is told on a papyrus, which today is in the Pushkin Museum in Moscow.

Herihor was succeeded by the high priest of Amen, Piankh, who led an unsuccessful expedition against Panehsy in Nubia. This marked the mysterious and inglorious end of the New Kingdom and the advent of a new era called the Third Intermediate Period.

The Third Intermediate Period, which covered the 21st to the 25th Dynasties (1081-656 B.C.), was a time of decentralization, when rulers of foreign origins appeared. The 21st Dynasty (1081-931 BC) saw two ruling parties: the family of Semendes I in the north, which ruled from Tanis (San el Haggar) in the east Delta; and that of the priestly military regime of Panedjem in the south, which ruled from Thebes.

At this time there were several instances of major tomb robberies, reflecting the corruption and the economic crisis at the end of the 21st Dynasty. The Theban populace was suffering from starvation and there were threats from Libyan tribes, in addition to public disorder. The kings of the 21st Dynasty, deciding that the safety of the royal tombs could no longer be guaranteed, began to move the royal mummies from their tombs in the Valleys of the Kings and the Queens for reburial in caches. Probably the removal of all the valuables from the tombs followed shortly afterwards.

In the 19th century, the royal mummies' cache in Deir al Bahri was discovered by a thieving family called Abd el Rasool, living in the village of Qurna,. They kept the discovery secret until it was finally revealed to the authorities and the Egyptologist Gaston

Maspero by one of the brothers, following a dispute between family members. As a result, Maspero transported the coffins and the mummies to Cairo in 1881.

The kings of the 22nd to the 24th Dynasties were the Meshwesh tribe of Libyan origin, which had lived for generations in Bubastis in the eastern Delta. The first king of the 22nd Dynasty, Sheshonq, is the best known of these kings. Staging a campaign against Palestine, the king commemorated the event on the walls of the temple at Karnak together with a list of the towns he had attacked. This campaign was mentioned in the First Book of Kings in the Old Testament, as taking place in the fifth regnal year of the Judean king, Rehoboam. It was described as an attack on Jerusalem by King 'Shishak'.

The 23td Dynasty ruled in parallel with the 22nd Dynasty, while the 24th Dynasty was based in Sais in the western Delta, and had two kings. One of them was Baccoris, who was remembered for issuing a series of laws.

The 25th Dynasty pharaohs were descendants of a family that had established itself in the land of Kush, in Upper Nubia, at the end of the New Kingdom following the loss of Egyptian power there. They were centred in Napata in Upper Nubia, but soon extended their power to Thebes. This rule ended with the Assyrian invasion of Egypt and the looting and plundering of Thebes by the Assyrians.

The throne of Egypt then passed to Psametik I, who had been a governor of Sais in the western Delta, and was a vassal of the Assyrians. He became the founder of the 26th Dynasty (664-525 BC), which is regarded as the beginning of the Late Period.

Psametik I (664-610 BC) united the cities of the Delta and Middle Egypt and with the help of a powerful Theban noble called Montuemhat, sent his daughter Nitokris to Thebes to become the wife of the god Amen. Her position of authority and highly important functions as a priestess rewarded her with great income and prestige in Upper Egypt. Accordingly after nine years, Psametik was in full control of the country.

During the 25th and 26th Dynasties, a number of distinguished tombs were constructed in the Theban necropolis, such as those of Harwa (TT 37) and Mentumhat (TT 34 in Assassif. Their owners were high ranking officials as well as high priests of Amen in Thebes. Moreover, there was a great revival in ancient art and architecture, known as 'archaism'. The sculptors of the Saite period looked back to examples of statuary and carved reliefs from the time of the Old Kingdom and copied them. In the south, the nobles copied the old Theban nobles' tombs of the same period. Also, the cults of dead kings were revived. They took great measures to assimilate the past and save the city from collapse.

The Persians led by Cambyses, conquered Egypt in the year 525 BC, marking the beginning of the 27th Dynasty (525-405 BC). This leader, who occupied Memphis, executed numerous locals, and was known for his cruelty, but he never damaged any of the

monuments in Thebes. Later he reconciled himself with the Egyptians, to gain their recognition.

His successor, Darius I, completed the canal that had been started during the reign of King Neko II (610-595 BC). He also constructed several temples in the oases.

Memphis had become the dominant city once more; the Greek historian Herodotus visited Egypt in 450 B.C. and left his accounts of it in his 'Histories', Book II.

King Nectanebo I, who founded the 30th Dynasty (380-343 BC), was an active builder of temples throughout the country. The road between Luxor and Karnak was refurbished and lined with new sphinxes. During his reign, the Persians tried to invade the country once again, but were routed by a flood. Nectanebo I believed that his piety had saved the country, and his successor, King Nektanebo II continued his temple building activities.

In 332 BC, the great Macedonian king, Alexander the Great, invaded Egypt during the reign of the Persian King Darius III. He met no opposition from the Egyptians, who had been very hostile towards the Persian occupation. He was crowned in Memphis and recognized as a divine pharaoh. Proceeding to Siwa Oasis, Alexander was supposedly accepted as the son of Amen by the oracle in the temple. He constructed a sanctuary in the temple at Luxor, where he was represented making an offering to the god Amen. His half brother Philippe Arrhideaus, constructed a sanctuary to Amen in Karnak. So began the Ptolemaic period of Hellenistic Egypt, which lasted until the Roman conquest in 30 BC.

Alexander the Great set an example, followed in the Greco-Roman period, of treating Thebes with great respect and trying to preserve and enrich it, in addition to revering the god Amen.

The Romans made several additions to the temples of Karnak and Luxor and repaired many ruined buildings. In addition, they started a temple dedicated to the goddess Isis (unfinished), a mile and quarter south of the temple of Medinet Hapu, on the west bank of the Nile just outside the Theban necropolis.

When Christianity came to Luxor there was a massive introduction of Christian religious symbols into the pagan constructions, tombs and temples. In addition, a number of churches were built around and over parts of the Theban temples.

Gradually, the city fell into decline; its monuments became buried in the sand carried by the desert winds over the centuries. Archaeologists and Egyptologists have worked hard over the years to restore the city to its former glory; they are still working in excavations, documenting and restoring the monuments of the city, trying to preserve the incomparable heritage of the glorious past.

THE PLATES

STATUE OF KING AMENHOTEP III, REPRESENTED ON A SLEDGE.

Pink granite, 18th Dynasty, reign of Amenhotep III, 1405 - 1340 BC,
Luxor Temple Cachette, Gallery A

Sculpted from pink quarzite, this superb statue was discovered in the Luxor Temple Cachette in 1987. King Amenhotep III is standing on a sledge set on a rectangular base. The face is elegant and refined with almond-shaped eyes typical of all his depictions. He is wearing the *sekhmty*, the double crown of Upper and Lower Egypt, with a protective cobra on his forehead and a false beard. He is standing in the traditional manner advancing his left leg forward, stepping over the nine bows representing the traditional enemies of Egypt. He is garbed in a pleated kilt adorned with a belt ending in four cobras that protect the cartouche on which his name is inscribed; his two hands are holding the royal seals.

Traces of gilding still exist on the multi-tiered *usekh* collar, armlets and bracelets.

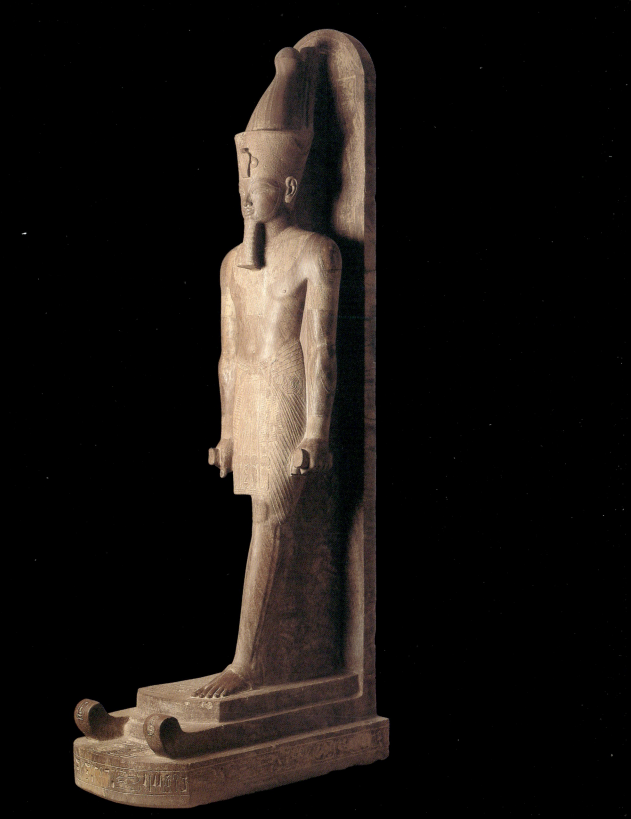

The base of the statue and the sledge are inscribed with his cartouches, as is the upper part of the stela forming the supporting back of the statue. In the king's cartouche on the base of the statue, the name of the god Amen was defaced on the orders of King Akhenaton during his revolutionary reign. This monotheistic pharaoh had the name of Amen removed from everything whether in temples or on statues, even those contained in his father's cartouches.

Sledges were the usual mode of transport in funerary processions to convey the coffin, chests, statues and other objects to the tomb. The sledge was used due to its religious significance, as seen in Chapter XXX of the Opening of the Mouth ceremony. In addition, the word for sledge in hieroglyphics was *tmt*, which had a symbolic connection with the god Atom. The deceased was believed to ascend to heaven on a sledge.

The statue was found with many others in the Luxor Temple Cachette, in the court of Amenhotep III at Luxor Temple in 1987. The discovery occurred during restoration work and operations dealing with underground water, and the construction of septic tanks in the temple precincts. Due to this major discovery of so many fine pieces, an extension was built onto the Luxor Museum to include a display of 16 of the most important statues. Some of these masterpieces were probably hidden by the temple priests to protect them from further destruction by King Akhenaton, during his religious revolution with its concentration on obliterating all traces of the god Amen. Other pieces found in the cachette dated to a later period.

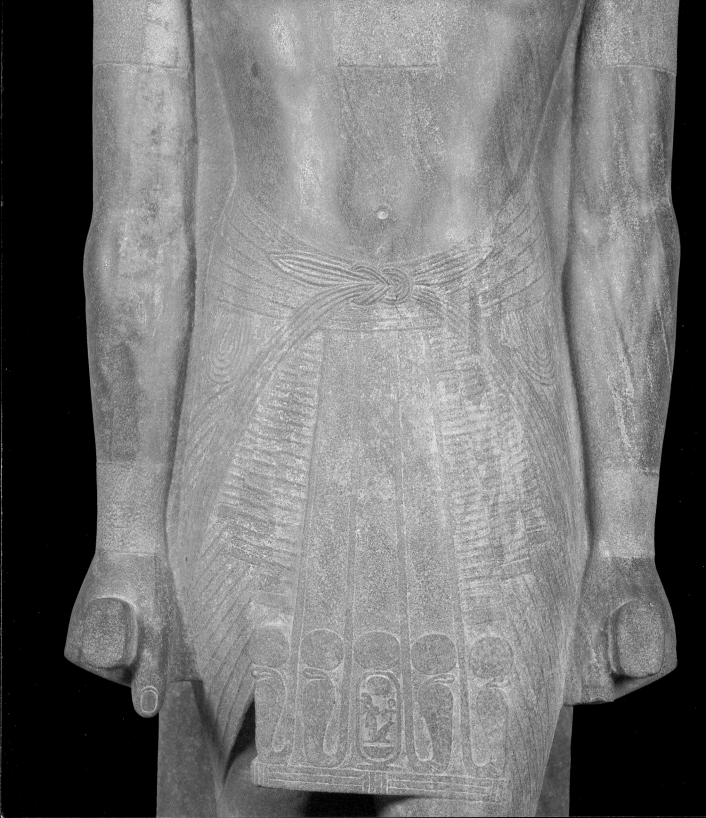

STATUE OF GODDESS IWNET

Granite, 18th Dynasty, reign of Amenhotep III, 1405 - 1367 BC, Luxor Temple Cachette, Gallery A

 This statue of the goddess was also discovered in the Luxor Temple Cachette in 1987. The goddess is depicted sitting on a throne, wearing a long wig and a long close fitting garment. She has a round face with full cheeks. Her right hand holds the *ankh* sign of life while the left is laid flat on her lap.

 This goddess was worshipped in Armant, some 6 miles south of Luxor. She was a member of the Theban Ennead called the *psdjet nedjset*, meaning the 'Small Ennead' that was to differentiate it from that of Heliopolis called the *psdjet aat,* meaning the 'Great Ennead'.

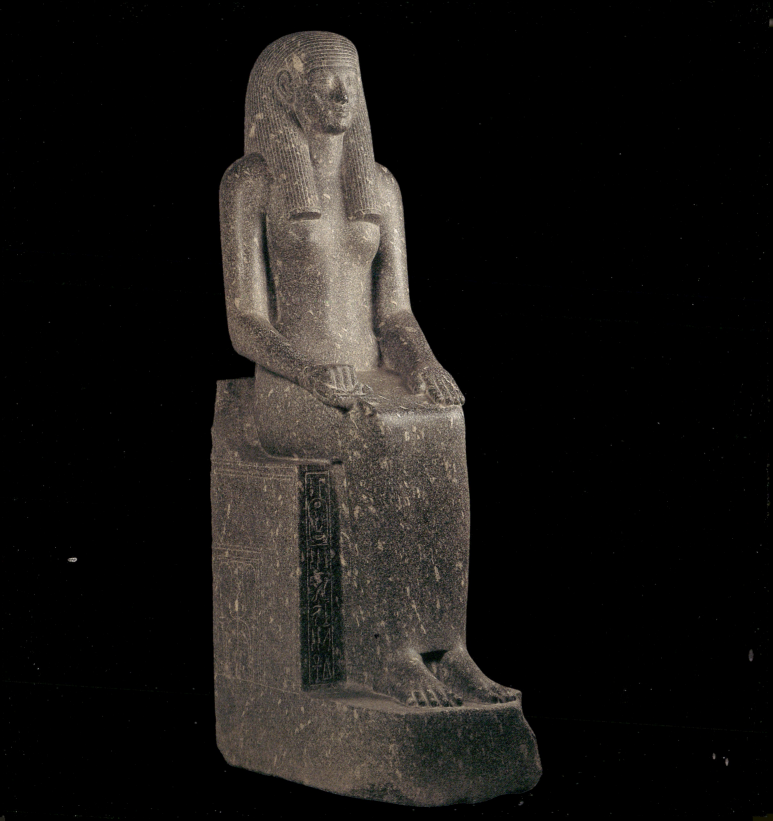

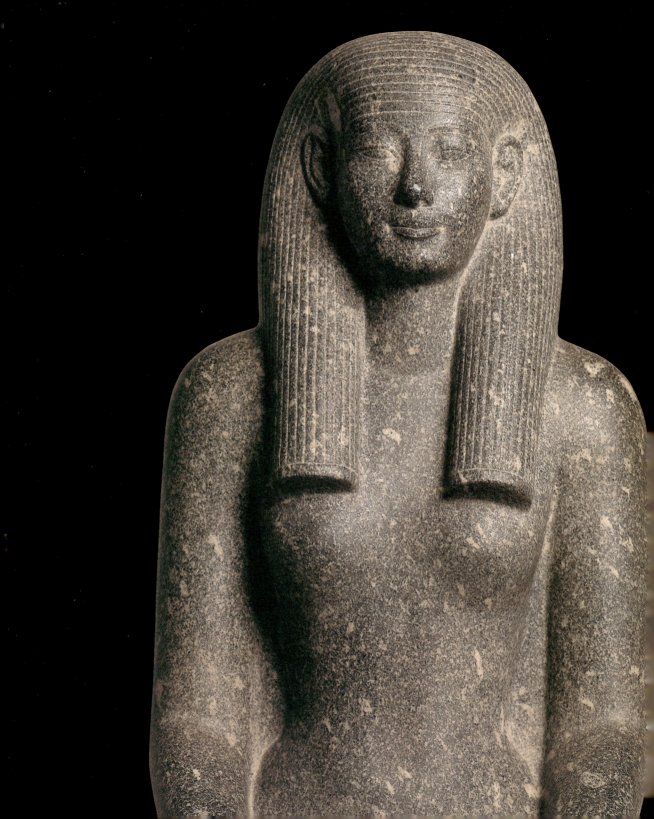

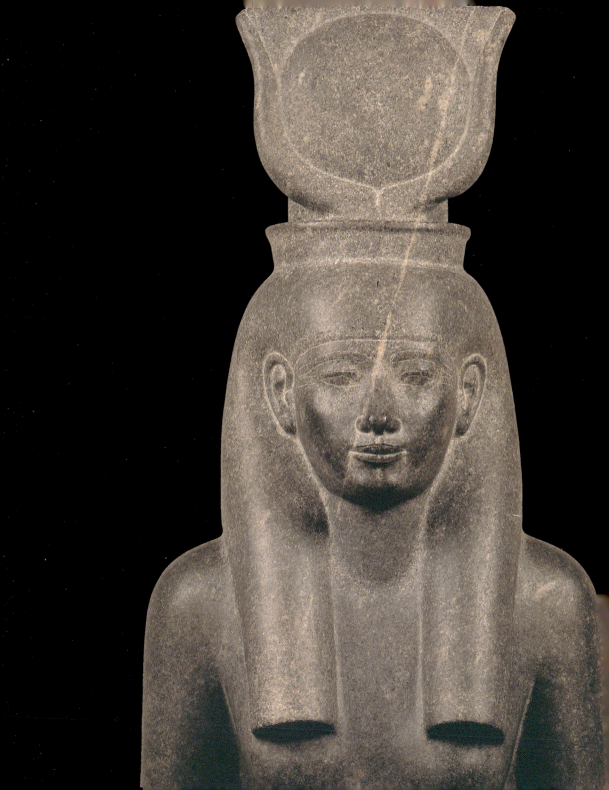

STATUE OF GODDESS HATHOR

Diorite, 18th Dynasty, reign of Amenhotep III 1405 - 1367 BC, Luxor Temple Cachette, H. 154 cm, Gallery A

Hathor is portrayed as a woman in this fine statue carved from diorite. She is dressed in a long close-fitting robe and is holding the *ankh* symbol of life in her right hand, while the left is placed on her lap. On her head she is wearing a long headdress topped by a diadem with the horns of a cow and a sun disc. She is seated on a throne with a back support.

King Amenhotep III dedicated this statue of the goddess to the temple. His name inscribed on the statue is *mry Hthr m ipt rsyt*, meaning "the beloved of Hathor in Luxor Temple"

The cow goddess Hathor was one of the most popular goddesses in ancient Egypt. In the Pre-Dynastic Period, she was venerated as the embodiment of fertility and nature, and she also played a role as a sky goddess. Hathor was the goddess of love, sexuality, beauty, joy, music and dance. She was worshipped in three forms: as a woman with the ears of a cow, in the shape of a cow and as a woman wearing a headdress consisting of a wig topped with horns and a sun disc. She was regarded as the royal mother, who suckled the king. In her vengeful aspect, she shared the leonine aspect of the goddess Sekhmet. She was worshipped in the form of the seven Hathor goddesses, who were a source of assistance during conception and determined the destiny of a child at birth. Her cult centres were as numerous as they were diverse: Memphis, Sinai and especially Dendara were major sites for her sect. At Dendara, Hathor was also invested with healing properties.

Associated, moreover, with papyrus marshes and vegetation, Hathor was sometimes depicted as a tree goddess, called 'the lady of the sycamore', who extended her care to the deceased, dispensing food and drink from her branches as well as offering shade. In her funerary role, she was a goddess of amiable character. She was known in Thebes as 'the lady of the Theban Mountains'; one belief surrounding this mythological figure was that she swallowed Ra, the sun god, each night, protecting him in her body so that he could be safely reborn the next morning. Likewise, Hathor was thought to aid in the regeneration of the deceased.

Her funerary epithets were: 'the lady of the Necropolis'; 'the lady of Thebes'; 'the lady living in western Thebes'; 'the lady of the West' and 'the lady of the desert'. Hathor's additional epithets were: 'the lady of turquoise; 'the lady of faience' and 'the lady of Byblos'.

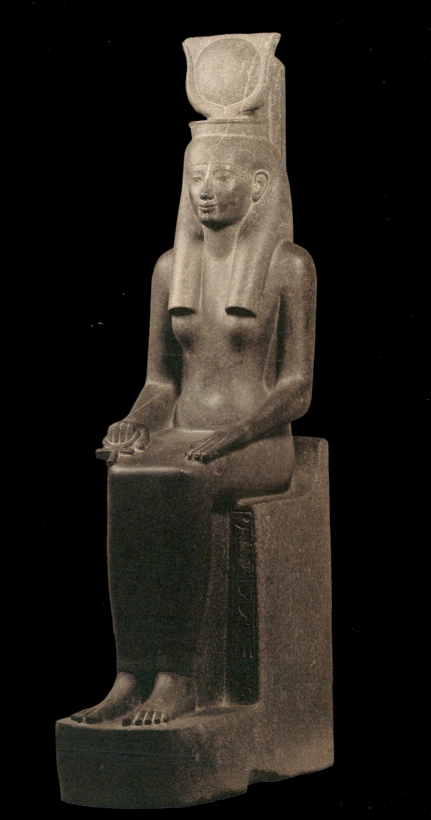

STATUE OF HOREMHEB BEFORE AMEN

Diorite, 18th Dynasty, reign of Horemheb 1338 - 1308 BC, Luxor Temple Cachette. H. 152 cm, Gallery A

King Horemheb is depicted standing before the seated figure of the god Amen, the great god of Thebes, in this exceptional statue. The god is wearing his crown formed of two upright feathers, a false curly beard and a pleated kilt. He is placing his right hand on the head of the king and his left is touching his arm in a blessing. The *sematawy* symbol on the side of the throne corresponds to the unification of the north and the south of the country. It consists of the seshen (lotus flower), symbol of Upper Egypt and the *wadj* (papyrus plant), symbol of Lower Egypt, tied together as they emerge from human lungs. The lungs symbolised the concept that the whole country, both north and south, was blessed by the god, who himself had given it the breath of life.

The king is standing in the traditional manner advancing his left leg forward and wearing the *nemes* (royal headdress). He has the royal cobra on his forehead and a false beard, and is wearing a short pleated kilt. In his right hand he is holding the *heka* or royal sceptre, symbol of power; in his left he holds his royal seal.

He took the name Horemheb Djeserkheperure, which means 'Horus is in feast, sacred are the forms of Ra', and so became the last sovereign of the 18th Dynasty. He had been granted several titles during the reign of Tutankhamun, among them 'the king's two eyes throughout the two banks'; 'the king's deputy in every place'; 'foremost of the king's courtiers'; 'overseer of the generals of the lord of the two lands'; 'overseer of every office of the king' and 'overseer of the overseers of the two lands'. Before ascending the throne he built a tomb at Saqqara, from which we can infer that he had led several military expeditions during the reign of Tutankhamun.

Horemheb was venerated during his lifetime and respect was paid to him at his unoccupied 'general's tomb' at Saqqara.

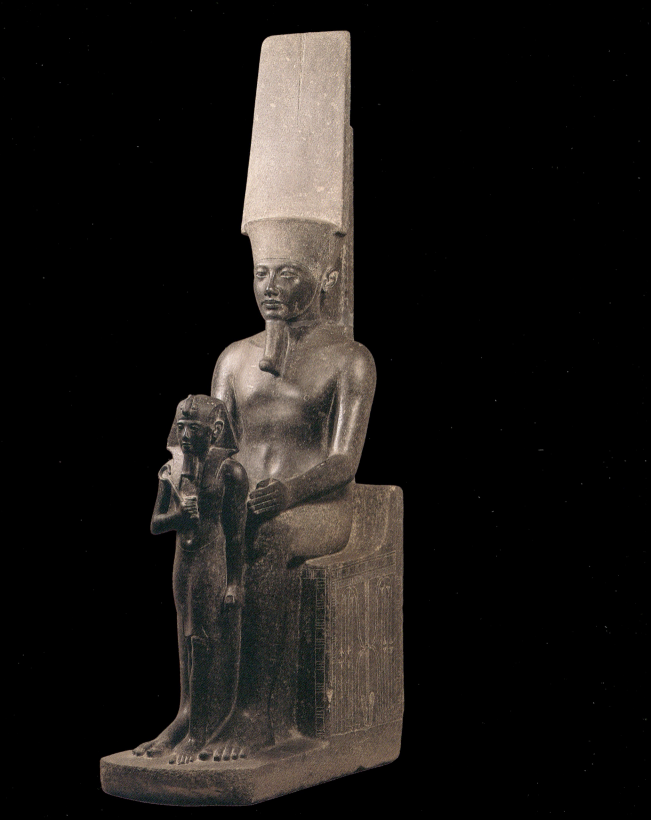

STATUE OF HOREMHEB AND GOD ATUM

Diorite, 18th Dynasty, reign of Horemheb 1338 - 1308 BC, Luxor Temple Cachette, Gallery A

This diorite statue was among those discovered in the Luxor Temple Cachette in 1987. King Horemheb is kneeling before Atum and presenting two *nw* jars of liquid offerings, probably milk or water. The king is wearing the *nemes* (royal headdress) and has a protective cobra on his forehead and a false beard.

The god is seated on a throne, the sides of which have the *sematawy* scene representing the unification of Upper and Lower Egypt by Hapy, the Nile River god.

Atum is wearing the double crown of unified Egypt. He was the sun god venerated in Heliopolis in the north of the country and was associated with the god Ra, eventually becoming the god Atum-Ra.

He was the head of the group of nine gods worshipped at Heliopolis, referred to as the 'Ennead of Heliopolis', symbolising the creation of the world. The primal world was believed to have been covered by a primeval ocean, and when the waters receded, the primeval hill appeared. The god Atum created himself and from his spit or sperm, he created Shu the god of the air and Tefnut the goddess of moisture and water. These two divinities then gave birth to Nut the sky goddess and Geb the earth god. In turn, this couple had four children: Isis, Osiris, Seth and Nephthys. Horus was the son of the union of Isis and Osiris. Atum was the guardian deity of kingship, protecting the king in his journey in the underworld.

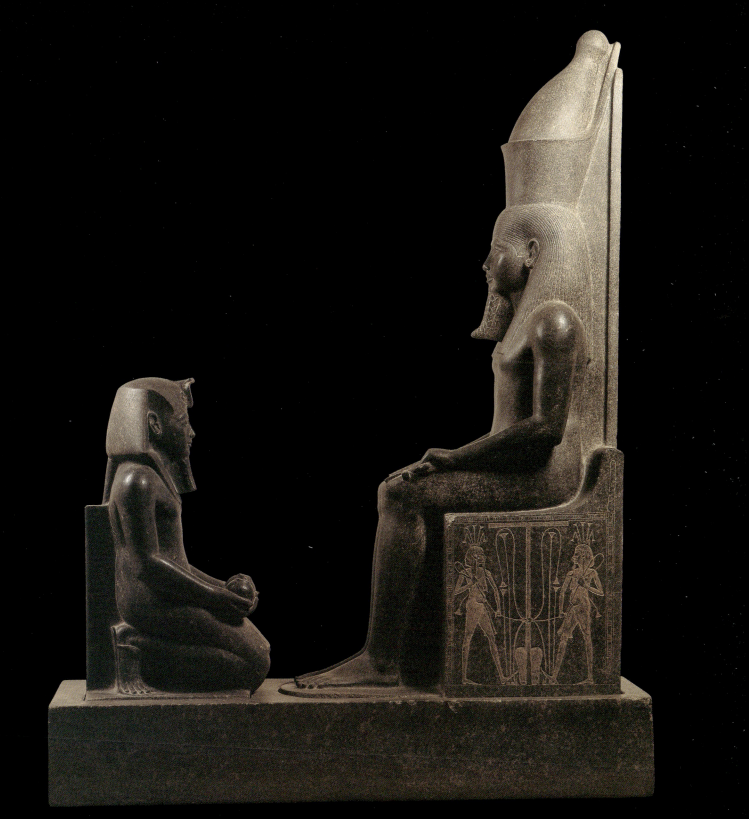

STATUE OF THE COBRA GOD AMEN KAMUTEF

Grey granite, 25th Dynasty, reign of Taharqa 689 - 664 BC, Luxor Temple Cachette, Gallery A

This statue of the cobra known as Amen Ka mutef is shown with the body in the striking position, coiled upright from behind. On the front are two shields, one of which symbolizes the goddess Neith, a powerful war goddess and the patron deity of Sais, the ancient Delta city.

The pedestal has the inscribed cartouches of King Taharqa, a Nubian king of the 25th Dynasty. He is described as King of Upper and Lower Egypt and 'beloved of Amen Kamutef'.

The 25th Dynasty kings were descendants of a family that had taken power in the land of Kush in Upper Nubia at the end of the New Kingdom, when there was a loss of Egyptian power in the region. They were based in Napata in Upper Nubia, but soon extended their rule to Thebes. Their reign ended with the Assyrian invasion of Egypt and the looting and plundering of Thebes by the conquerors.

Amen Kamutef means literally 'the bull of his mother'. It was one of the many forms of the god Amen, 'the one who completed his moments'. He was a creator god, who was able to resurrect himself by taking the form of a snake and shedding his skin.

Several goddesses like Wadjet the protective deity of Lower Egypt, took the shape of a sacred cobra, as did Meryt seger, the funerary goddess of the Theban necropolis.

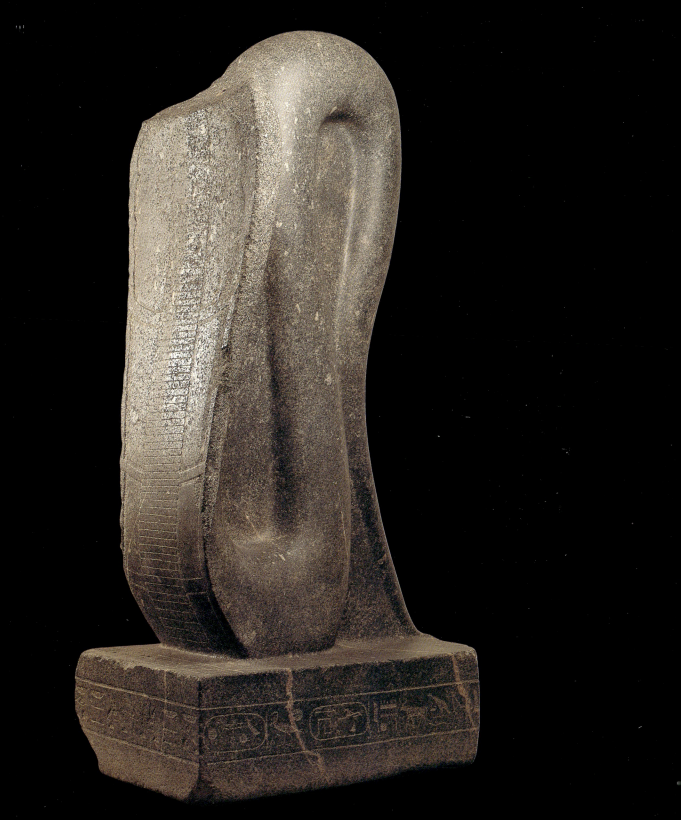

COLOSSAL HEAD OF AMENHOTEP III

Pink granite, 18th Dynasty, reign of Amenhotep III 1405 - 1340 BC, Qurna, H. 215 cm, Gallery B

This remarkable colossal head of Amenhotep III was discovered in his funerary temple in Qurnah, on the west side of the Nile in Luxor in 1957.

The king is wearing the *hedjet*, the white crown of Upper Egypt, with a cobra on his forehead and a false beard. The face is beautifully proportioned and elegant, with the almond shaped eyes and flat lips typical of his statues.

Amenhotep, whose mother Mwtemwia was only a minor wife probably from the tribe of the Mittani, had to overcome the question of his legitimacy to justify his ascension to the throne. The pharaoh, like others before him, therefore had to validate his position by relating the story that he was 'the divine son of the god Amen, begotten of him and born under the protection of the gods'. He had this story depicted in a room beside the sanctuary in Luxor Temple. The god Khnum is shown moulding the body and *ka* of Amenhotep on the potter's wheel. The goddess Isis embraces his mother in front of the god Amen, who is led by Thot, the god of wisdom to the queen's bedchamber where he approaches her to beget the child, already shaped by Khnum. The pregnancy is attended by Bes and Taweret, the divine gods of childbirth. After the delivery, Amen holds the child in the presence of the goddess Hathor.

Amenhotep III sent a punitive expedition to Nubia, afterwards constructing a temple and a fortress at Soleb. His main building activities included the third pylon at Karnak and the southern half of Luxor Temple. In addition a palace and a residential complex including houses for his family and close court officials on the west bank of the Nile at Thebes, at the site now called Malqata, were erected. He also built a great mortuary temple on the western side of the Nile, now mostly lost apart from the two colossi that stood in front of its pylon, now called the Colossi of Memnon.

Diplomatic correspondence between Amenhotep III and neighbouring Western Asiatic rulers is recorded in the Amarna letters, which are cuneiform tablets found at Tel al-Amarna. These relate how Amenhotep married princesses from Western Asia to cement alliances and maintain peace, and how the Hittites attacked the Mittani.

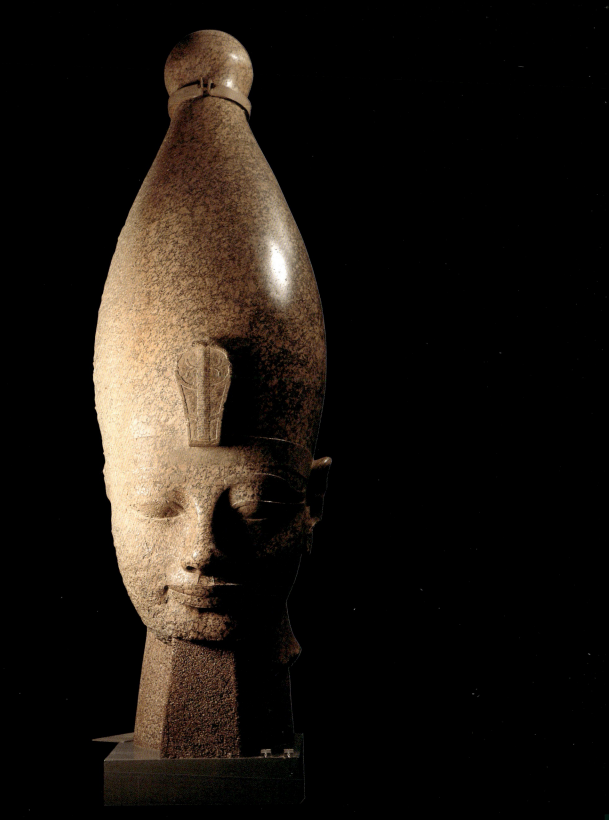

TUTANKHAMEN AS GOD AMEN

Limestone, 18th Dynasty, reign of King Tutankhamen 1355 - 1346 BC, Karnak Temple Cachette, H. 155 cm, Gallery B

This statue was found in 1902-1903 by the French Egyptologist George Legrain, in the so-called Karnak Temple Cachette; a secret hiding place underneath the courtyard in front of the seventh pylon at the temple. The cachette contained thousands of statues of pharaohs, private individuals and deities dating from the 11th Dynasty to the Ptolemaic period. King Tutankhamen is wearing a crown formed of two upright feathers in his role as the god Amen, the great god of Thebes. He is standing in the traditional manner advancing his left leg forward, and is wearing a large *usekh* collar and has the false royal beard. In his two hands he is holding the protective *tit* amulet of the goddess Isis.

The king was only eight or nine years old when he succeeded to the throne, so he was under the regency of the priest Ay, who, doubtless much to the relief of the people moved the court and administration back to Thebes from Akhet Aten and restored the old cult of Amen-Ra and the worship of the other divinities throughout the land. Twt-ankh-aten, 'the living image of the god Aten', changed his name to Twt-ankh-amen when he moved back to Thebes, while his wife and half-sister Ankh-es-en-pa-aten, 'the one who lives for the Aten', in turn changed hers to Ankh-es-en-pa-amen. By the end of the 18th Dynasty the cult of the Aten had been almost completely wiped out.

When Tutankhamun died leaving no heir, his wife Ankhesenpaamen became the heroine of the final crisis of the lingering shadow cast by the Amarna Period. She wrote to the Hittite king Shuppiluliuma I begging him to send her a prince to take in marriage, since no suitable man could be found for her in Egypt. "Never shall I take a servant of mine and make him my husband!" she wrote. The Hittite king overcoming his surprise sent one of his sons, Prince Zannanza, but the potential bridegroom died on the way, probably murdered by Ay, who was destined to become the next king.

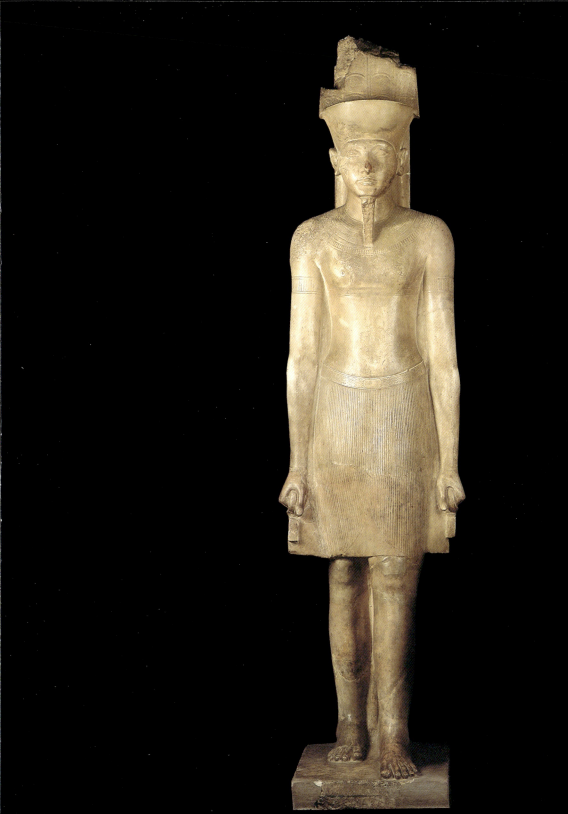

HEAD OF SENUSERT III

Pink granite, 12th Dynasty, reign of Senusert III 1878 - 1843 BC, Karnak, H. 80 cm, Gallery C

This head of King Senusert III was found in front of the fourth pylon in Karnak Temple in 1970. The king is shown with sunken eyes, a small mouth and big ears and is wearing the *sekhmty*, the double crown of Upper and Lower Egypt. On the forehead, we see the cobra symbolizing royal protection.

He appears exhausted and the wrinkles around his eyes both accentuate this and suggest his advanced years.

Senusert III was an aggressive administrator and a shrewd warrior. This statue was carried out after he had led several long campaigns to Nubia and Palestine to restore Egyptian power and prestige. The peaceful policies of his predecessors Amenemhet II and Senusert II had encouraged many tribes to revolt and make a bid for power. Some managed to cut the commercial routes between Egypt and Nubia in the south, and Palestine and Lebanon in the northeast. Senusert III had a channel excavated through the rocks around the First Cataract to facilitate the movement of his army and fleet of boats. He also increased the number of hill fortifications along the Nile and on the island between Aswan and Wadi Halfa, and the First and Second Cataracts. Some of these fortifications consisting of walls twelve yards wide surrounded by towers containing army barracks, still stand in Semnah and Kemnah, north of Wadi Halfa. He placed two granite stelae there promulgating his policy on securing the frontier.

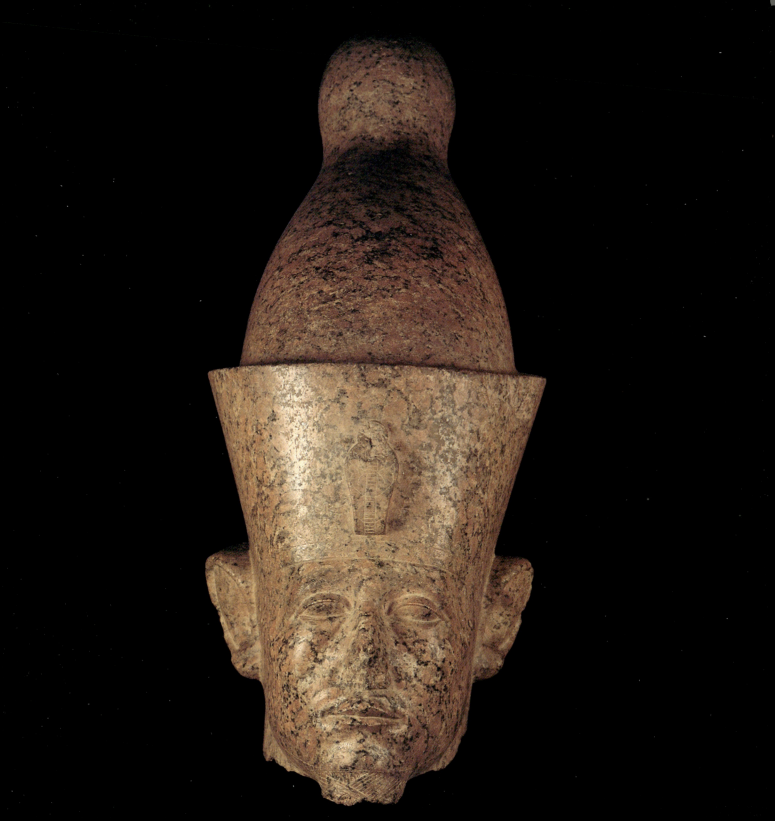

Senusert's name *S-n-wsrt kha-kaw-re* meant 'the one who belongs to the goddess *Wsrt*, may the double of the god Ra shine'. He was honoured by his people during his lifetime and four centuries after his death, the glorious 18th Dynasty warrior King Tuthmosis III erected a stela in his honour.

Other building projects during his reign included erecting a statue and a limestone gate in the temple of the war god Montu at Medamud, five miles northeast of Luxor. On the wall is a relief of Senusert's sed festival, showing him seated under the double-throned festival pavilion, while the gods Horus and Seth offer him the *ankh* symbol of life.

Senusert's pyramid at Dahshur was built of mud bricks and encased with limestone. Exquisite jewellery was found in the graves of the female members of his family who were entombed nearby.

Like the other members of the 12th Dynasty who shared his name, Senusert was called Sesostris by classical Greek historians. They attributed to him, or more probably it was Senusert I, the digging of a canal between the Red Sea and the Nile to facilitate the transport of goods.

STATUE OF AMENEMHAT III

Black granite, 12th Dynasty, reign of Amenemhet III 1843 - 1797 BC, Karnak, Gallery C

This standing statue of Amenemhet III sculpted from black granite was found in Karnak. He is wearing the *nemes* (royal headdress) with the cobra on his forehead, and is clothed in a short, starched kilt decorated with geometrical patterns ending in two cobras. The king is portrayed in the praying position with his arms beside his body and his open hands placed over the kilt, thus showing himself not as a divine god but as a person offering devotion. His names and titles inscribed on the base of the statue describe him as 'the beloved of Amen-Ra, Lord of Karnak'.

Amenemhet is represented here as a middle-aged man and this is a fine example of the blending of two artistic styles; that of the idealized Memphis school with that of the more naturalistic Theban school. This fusion resulted in a very traditional representation of the body with squared shoulders and strong muscles, with at the same time very realistic details of the world-weary facial features. The figure is shown in a new praying position, which came into vogue at this period.

This statue also reflects the prevailing beliefs regarding the divinity of the sovereign. In the Middle Kingdom he was no longer represented as a god, but as making obeisance to a god to ensure the welfare and prosperity of his country. Meanwhile, the god bestows his blessing on him and helps him to overcome his enemies and the forces of cosmic disorder.

This is an example of the Middle Kingdom approach of showing individual character in the royal statues, rather than representing the sovereign as a god, like the rulers of the Old Kingdom.

Amenemhet III, sixth king of the 12th Dynasty, ruled for forty-six years, during which time he was in charge of a highly centralized government. He devoted much energy to building and urban activities, having inherited a country where the government was in a full control of all mines, quarries and commercial routes in the south and the northeast. Numerous graffiti left by members of mining and quarrying expeditions testify to the amount of activity during his reign. Amenemhet III began a pyramid at Dahshur, but when it partially collapsed, he built a second at Hawara instead, five miles southeast of Fayoum.

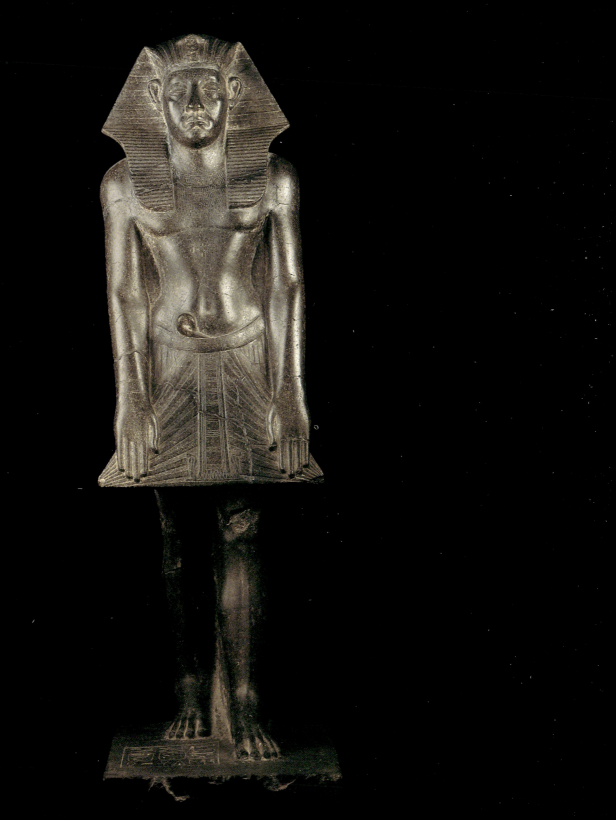

Amenemhet III completed many great agricultural projects in Fayoum, some of which may have been initiated during the reign of his grandfather Senusert II (1897 to 1877 BC). The amount of cultivated land was increased; while the Nile's waters were diverted and stored in Lake Moeris in the Fayoum depression via a nine-mile long channel, for use in dry seasons or in years of low flood waters. The channel was to allow the water to flow into the depression during high floods. Amenemhet III had the channel widened and deepened and added an earthen dam called ra-hent, or the mouth of the lake, with gates by means of which the rise and fall of the water was regulated. This site was later called Lahent, and later still El Lahun.

Classical historians linked Amenemhet III, whom they referred to as Lamarres, with a huge construction at Hawara in Fayoum now called the Labyrinth. This building consisted of two floors and had over three thousand rooms. Some descriptions mention that the Labyrinth was actually several palaces linked together by means of an elaborate network of passages, and that one needed a guide so as not to get lost. Archaeological research indicates that this building was actually a huge mortuary temple built beside the pyramid of Amenemhet III for his funerary cult.

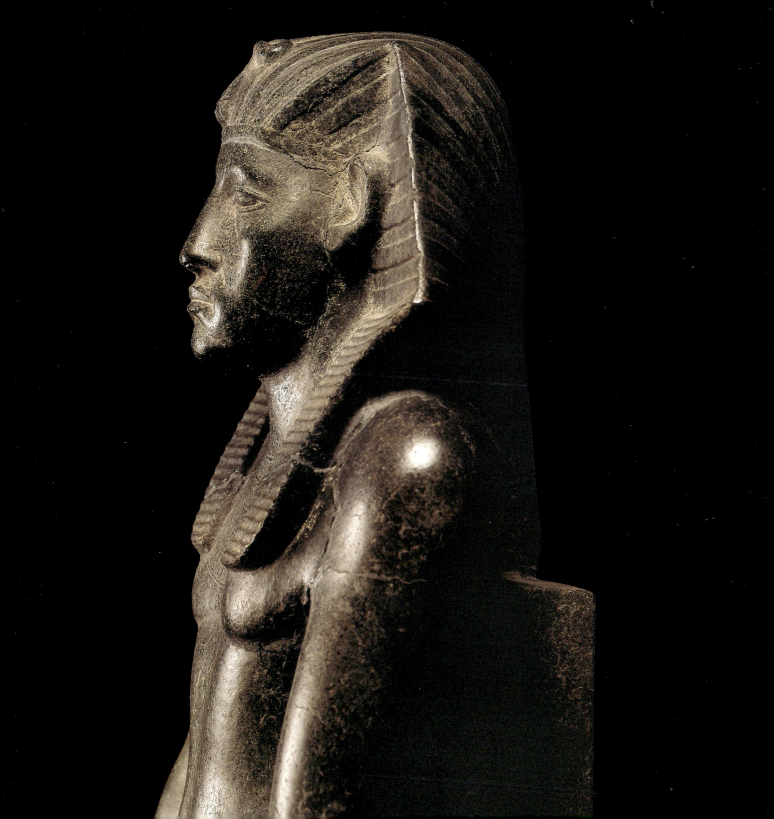

RELIEF OF THE GOD AMEN

Limestone, 18th Dynasty, Reign of Tuthmosis III 1504 - 1452 BC, Deir el-Bahri, Gallery C

This well preserved low cut relief was found in 1962 in the el Deir el Bahri area. It shows the god Amen wearing his traditional crown consisting of two upright feathers, a curly false beard and a multi-tiered *usekh* collar. His face is painted black, which was the colour of fertility and resurrection.

The god Amen, whose name meant 'the hidden one', was one of the most important ancient Egyptian gods who was mentioned in the Pyramid Texts as early as the 5th Dynasty. He was worshipped as a local deity in Thebes during the 11th Dynasty; while in the 12th Dynasty he was regarded and described as 'The king of the gods'. Apart from being represented as a man wearing a two plumed crown, he was also depicted as a ram or sometimes as a human with a ram's head.

In addition, he was combined with the god Re into Amen-Re, who eventually became the Theban representation of the solar god.

He was also associated with the Min, the fertility god of Coptos, north of Thebes.

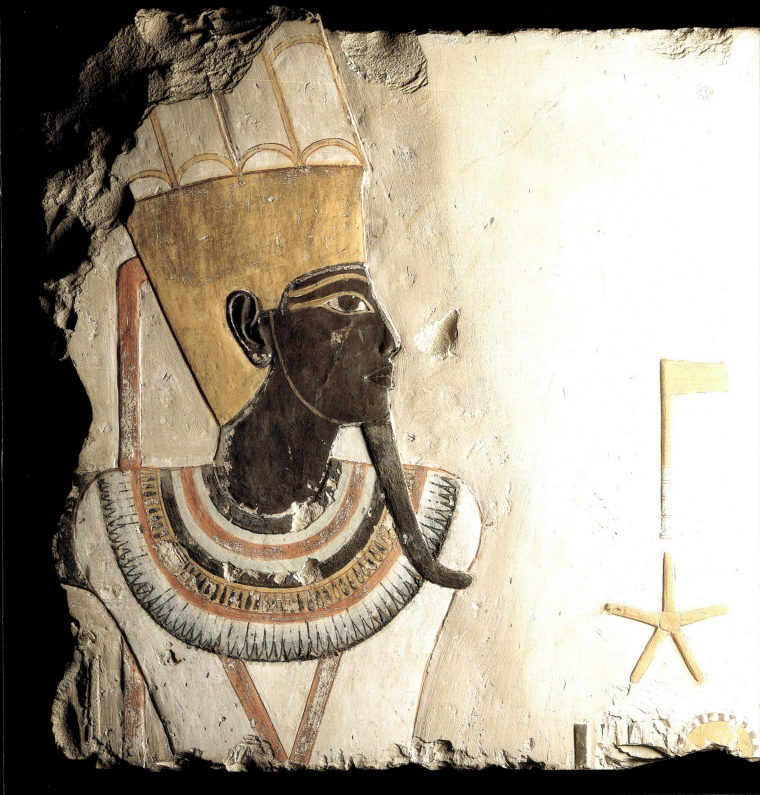

STANDING STATUE OF TUTHMOSIS III

Greywacke, 18th Dynasty, reign of Tuthmosis III 1504 - 1452 BC, Karnak Temple Cachette,
H. 90.5 cm, Gallery C

This extraordinary statue of King Tuthmosis III was found in 1904 in the Karnak Temple Cachette. It shows the king standing in the traditional royal pose advancing his left leg forward. He is wearing the *nemes* (royal headdress) with the royal protective cobra on the forehead. He has a false beard and is clothed in the pleated *shendyt* (royal kilt). In his hand he is holding the royal seals. His name is inscribed in the cartouche on his belt buckle. The fine polish and quality of workmanship of the piece are remarkable and reflect a highly developed artistic sense combined with great technical skill.

His statues always show the face of Tuthmosis as imbued with strength and nobility and of an elegant style for which he was well-known.

During his long reign King Tuthmosis extended the Egyptian empire, spending twenty years of it in leading military expeditions. The royal scribes, who accompanied the king on these campaigns, inscribed a series of annals at Karnak. Considered the longest and most valuable historical records of ancient Egypt, these give full information about Tuthmosis' achievements in Western Asia during seventeen campaigns. There are fascinating details such as of the spoils from these battles, which included gold vessels and gilded chariots. Tributes, such as silver, lapis lazuli, wine, timber for boat building and a metal alloy called Asiatic copper, also came from Western Asia as well as Nubia.

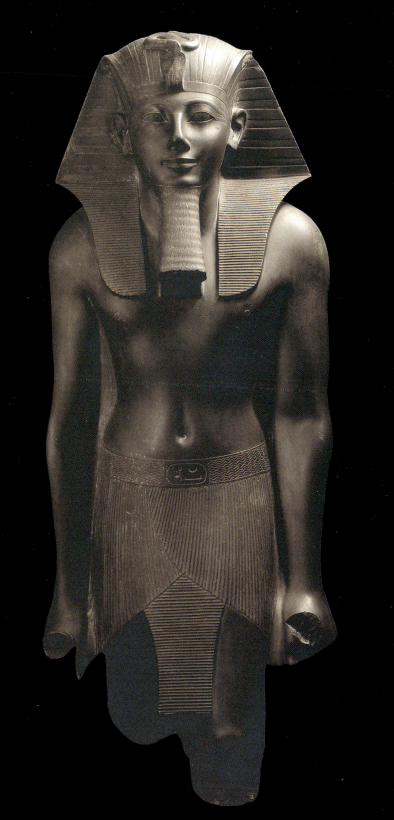

Conducting his campaigns in summer, the pharaoh would return to Egypt in winter to supervise building operations. Tuthmosis' first campaign began soon after he succeeded Hatshepsut, following her death. This battle revealed his strategic brilliance when he led fifteen thousand soldiers to Gaza, travelling from Tharo fort on the eastern frontier for nine days. He spent one day in Gaza where he celebrated his coronation feast, and then travelled for another twelve days. At one point, the king had to choose between three roads: one very narrow and two others that were wider. When consulted, the military chiefs suggested avoiding the narrow road, which might be dangerous and tiring, allowing as it did for horses to pass along it only in single file. Tuthmosis, however, decided to take it and surprise the enemy. This he did, besieging the city of Megiddo for seven months until its defenders surrendered.

A list at the temple enumerates the one hundred and nineteen towns that were conquered during this first campaign. The conquered territories are shown in an oval-shaped scene surmounted by a male bust, with the Syrians depicted with pointed beards and their arms tied behind their backs.

The eighth campaign in year 33 of Tuthmosis' reign was also memorable. Before setting out to launch an attack on the king of the Mittanis, he prepared a fleet of boats off the Lebanese coast. He then had them dismantled and transported by road for two hundred and fifty miles on oxcarts. At Carcemish, on the Euphrates, he reassembled these boats and conducted a triumphant naval battle.

Tuthmosis' reputation for diplomatic brilliance was attested to by his policies. He never, for example, appointed an Egyptian governor over the conquered territories, empowering local chieftains instead. He also forged cultural relations by bringing the various leaders' sons to study in Egypt to absorb its culture, religion and civilisation, before returning to their own land. In addition, the king extended his commercial relations with the 'Genbetiew' tribes in the Arabian Peninsula.

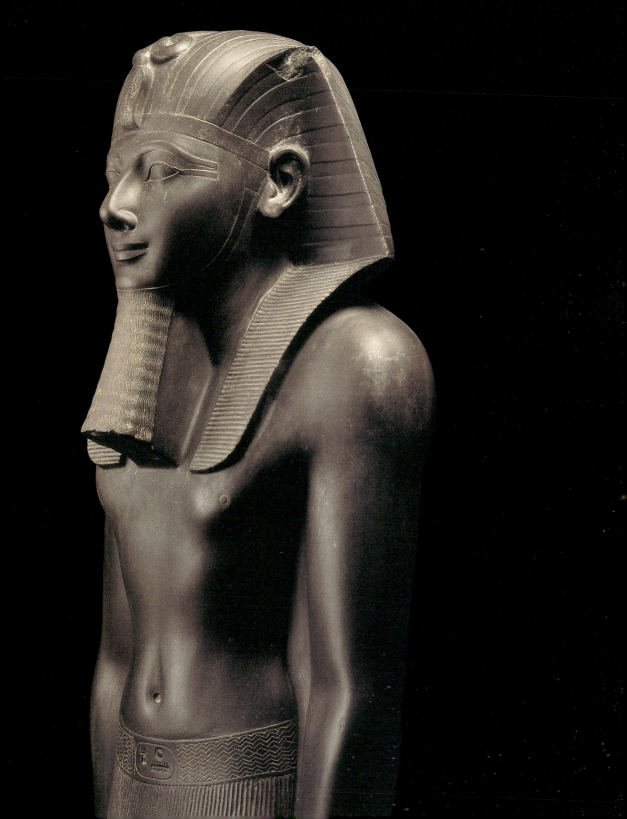

TUTHMOSIS III WEARING THE ATEF CROWN

Limestone, 18th Dynasty, reign of Tuthmosis III 1504 - 1452 BC, Deir el-Bahri, Gallery C

The low relief mural found in the el Deir el Bahri area, shows King Tuthmosis III wearing the *atef* crown consisting of the *hedjet* or white crown of Upper Egypt with a pair of ostrich feathers, typical of Osiris the god of the realm of the dead. The crown is surmounted by a horned solar disc; there is a protective royal cobra on his forehead and he has a false beard. The condition of the colours is truly remarkable as they have hardly faded at all.

The wealth of the country enabled Tuthmosis to undertake ambitious building works. His contribution at Karnak included the sixth pylon and the hall of records, where state records, compiled by temple priests, listed the gifts and booty acquired during the pharaoh's successful campaigns. He also erected two heraldic granite pillars; one of which bore the lotus of Upper Egypt and the other the papyrus of Lower Egypt, both carved in high relief.

Tuthmosis further built the festival temple. *Akh menw*, 'the most glorious of monuments'. While the rest of Egypt was intoxicated with feelings of national pride, the victorious king was modestly giving thanks to the god Amen, by raising his temple at Gebel Barkal in Nubia, at the Fourth Cataract. There, he inaugurated the cult of the god Amen.

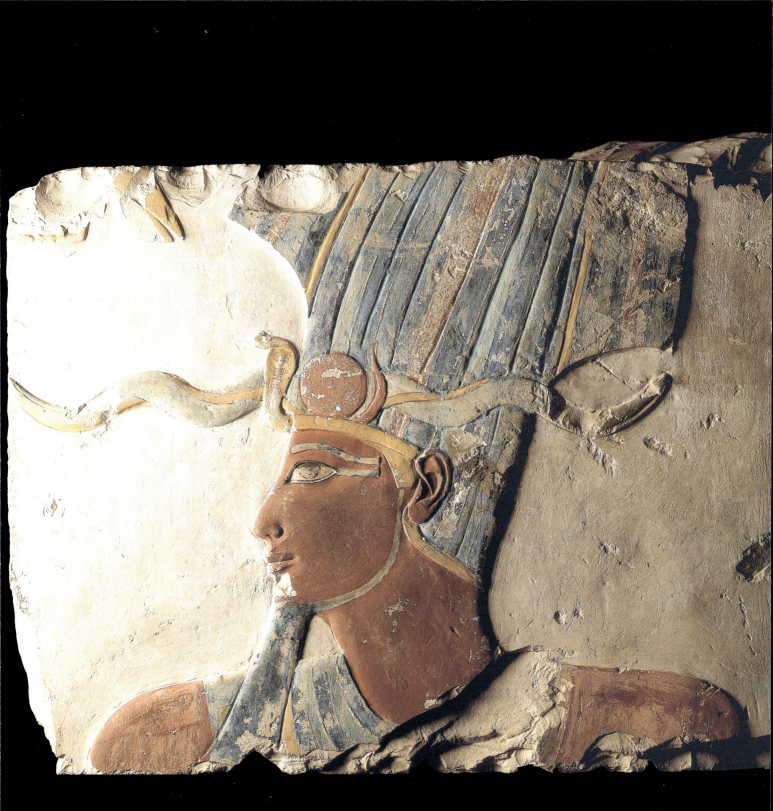

STATUE OF THE CROCODILE GOD SOBEK

Granite, New Kingdom, Dahmasha, Armant, H. 21.7 cm, Gallery C

This statue of Sobek the crocodile god representing the Nile flood and fertility was discovered in 1967 in Dahmasha near Armant, south of Luxor. He was associated with the sun god Ra and worshipped as the god Sobek-Ra. Sobek was depicted either as a crocodile or a man with the head of a crocodile. His first and oldest cult centre was at Shedet in Fayoum, later called Crocodilopolis by the Greeks. During the Middle Kingdom, when the Egyptian kings paid more attention to the Fayoum region, he became a great state god, especially during the reign of King Amenemhet III. Amenemhet III was deified in Fayoum at a later period, with his divine triad consisting of the king, Sobek and the goddess Rnnwett

Sobek was worshipped in the region of Gebel el Selsela; in a temple north of Kom Ombo in Upper Egypt; and a further temple dedicated to this god was built on the site during the Greco-Roman period. He was a member of one of two triads worshipped there: the first was that of Sobek, his consort Hathor and their son Khonsu Her; the second consisted of the solar war god Horus the great or Haroer, his wife Ta-sent-nefert (good sister) and their son Panebtawy (Lord of the Two Lands). A large number of mummified crocodiles were discovered in one of the secret underground crypts in the temple at Kom Ombo.

In addition, sanctuaries which were assigned to his worship had a small pool for the sacred reptiles.

In the Theban province, Sobek was worshipped in Gebelein, sixteen miles south of Luxor and in Dahmasha near Armant, some six miles south of Luxor, where there was a sanctuary for the sacred crocodiles in the 18th Dynasty.

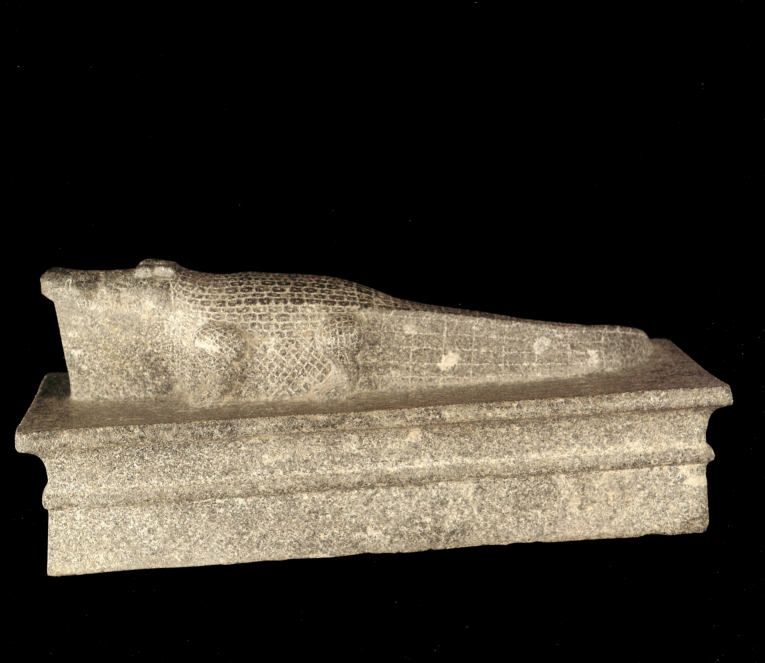

GOD SOBEK WITH AMENHOTEP III

Alabaster, 18th Dynasty, reign of Amenhotep III 1365 - 1340 BC, Dahmasha, Armant, H. 256.5 cm, Gallery C

Found in 1967, this outstanding statue sculpted from a single piece of alabaster depicting the crocodile god Sobek and King Amenhotep III, is one of the jewels of Luxor Museum.

The god-is represented as a crocodile-headed man sitting on a throne. He is wearing a crown consisting of a horned sun disc and two upright feathers, and has a cobra on his forehead. He is placing the *ankh* sign of life in front of the king promising him eternal life. The king is wearing the nemes (royal headdress), a starched *shendyt* (royal kilt) and has the protective cobra on the forehead. He is portrayed in a position of prayer with his arms beside his body, and his open hands placed on the kilt.

Some two hundred and fifty statues of King Amenhotep III have been found, along with a series of memorial scarabs, on which are recorded several events from his life, such as the arrangements of his marriage to Queen Tiye and his highly successful lion hunts.

Queen Tiye was the queen consort of Amenhotep III. The daughter of Yuya, she came from Akhmim in Middle Egypt. Tiye was a very important and influential queen during the reigns of both her husband and son. Her position and status are attested to by several monuments and statues, showing the queen in the company of Amenhotep III during cult events and the *sed* festival. Her role with regard to the king was compared to that of the goddess of justice, Maat as she followed the sun-god Re.

Although Akhenaten intended to bury his mother in his new capital, she was eventually laid beside her husband in the Valley of the Kings. A lock of Queen Tiye's hair was found among the treasures of Tutankhamun, demonstrating his great love for his grandmother.

Amenhotep III also married two of his daughters; one of them was called Setamun. When his heir and first-born child Tuthmosis met a premature death, his younger son Amenhotep, who later renamed himself Akhenaten, became Crown Prince.

At the back of the statue are the titles and cartouches of Ramsses II: *Ra mss mry imn*, *User maat Re stp in Ra*, who was well known for inscribing these on the buildings and statues of earlier kings. Some Egyptologists called him 'the usurper king', while others have since discovered that it was probably done as a sign of protection and in appreciation of its original owner.

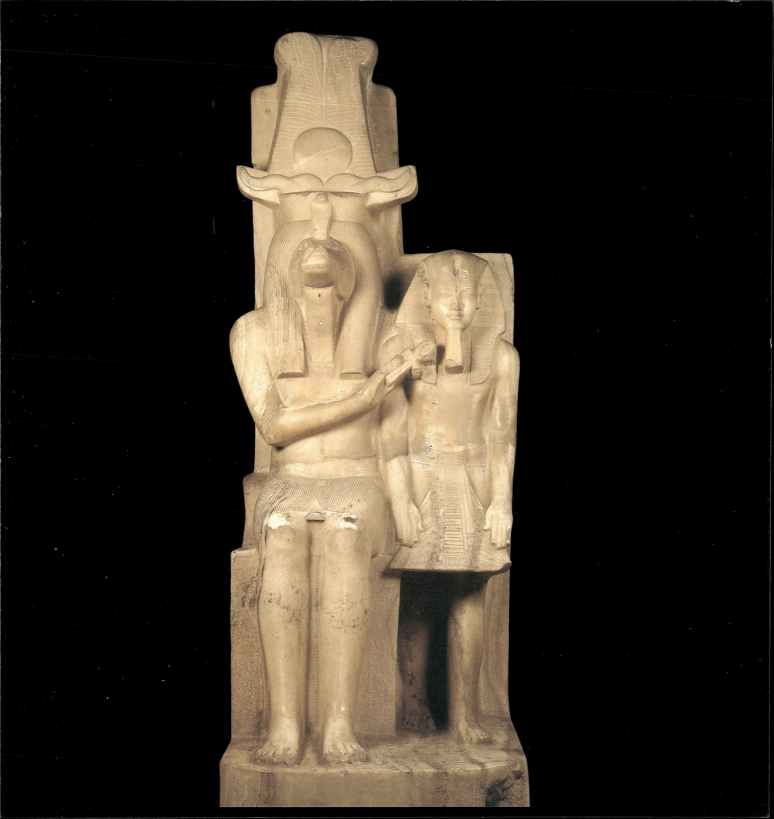

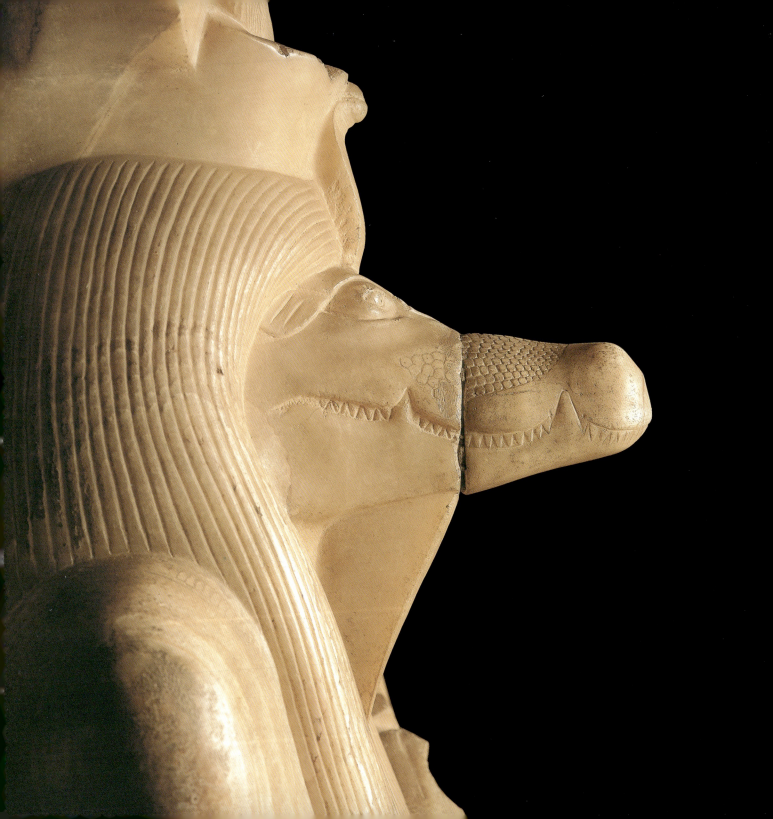

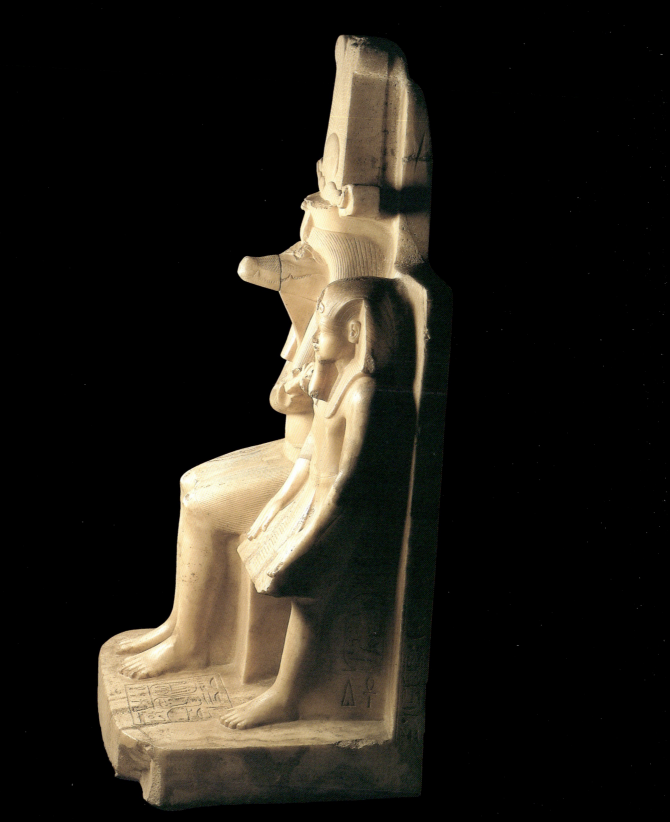

STELA OF PIA

Limestone, 18th Dynasty 1569 - 1315 BC, Dahmasha, 110.5 cm, Gallery C

This round topped stela was found in 1967 in the temple of Sobek in Dahmasha. This is one of a great number of votive stelae that were presented in temples and sanctuaries, dedicated to gods by individuals as an expression of their personal devotion.

It is dominated by large images of the god to whom the stela is dedicated and contains a short text and a depiction of the dedicator in adoration before the god.

Here we have Pia, the high priest of Sobek wearing a leopard skin and venerating the god, represented in his form as a crocodile-headed man. The god is wearing a crown topped by a horned sun disc and two upright feathers, and is sitting on a throne under a sacred tree in the company of a goddess. In front of the gods we see an offering altar, jars and a bouquet of lotus flowers. Pia is followed by his father in the first register; in the second, in addition to his father, he is accompanied by his wife and sisters praying to Sobek and again presenting offerings including jars, bouquets and a sistrum.

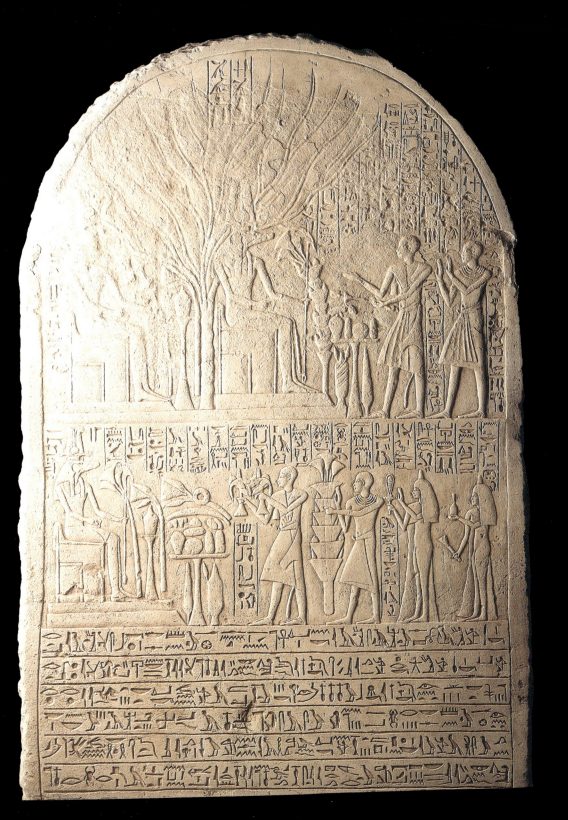

GOD AMEN AND HIS WIFE THE GODDESS MUT

Black granite, 19th Dynasty, reign of Seti I 1314 - 1304 BC, Gallery C

The dyad shows Amen, the great god of Thebes and a state god during the New Kingdom, sitting on a throne in the company of his wife the goddess Mut.

Amen is wearing his crown composed of two upright feathers (destroyed), a false curly beard, and jewellery, which includes a multi-tiered *usekh* collar, two armlets and two bracelets. His right hand is lying open on his lap while his left holds the *ankh* sign of life. Mut is wearing the *sekhmty* double crown of Upper and Lower Egypt on top of a long headdress in the shape of a vulture. She is also is adorned with a multi-tiered *usekh* collar, two armlets and bracelets. Her close fitting dress reveals the contours of her body and the position of her hands replicates those of Amen.

Mut was the consort of Amen in the 'Theban Triad'; their son was the god Khonsu, the moon god. Like Isis and Hathor she was regarded as a divine mother as her name Mut literally meant 'the mother'. She was sometimes linked to the lioness goddess Sekhmet in her aggressive aspect and was regarded thus as the eye of Ra sent to terrorize guilty people on earth.

Inscribed on the throne between the couple are the titles and names of King Seti I, who is described as 'the good god, the son of Re and the beloved of Amen and Mut'.

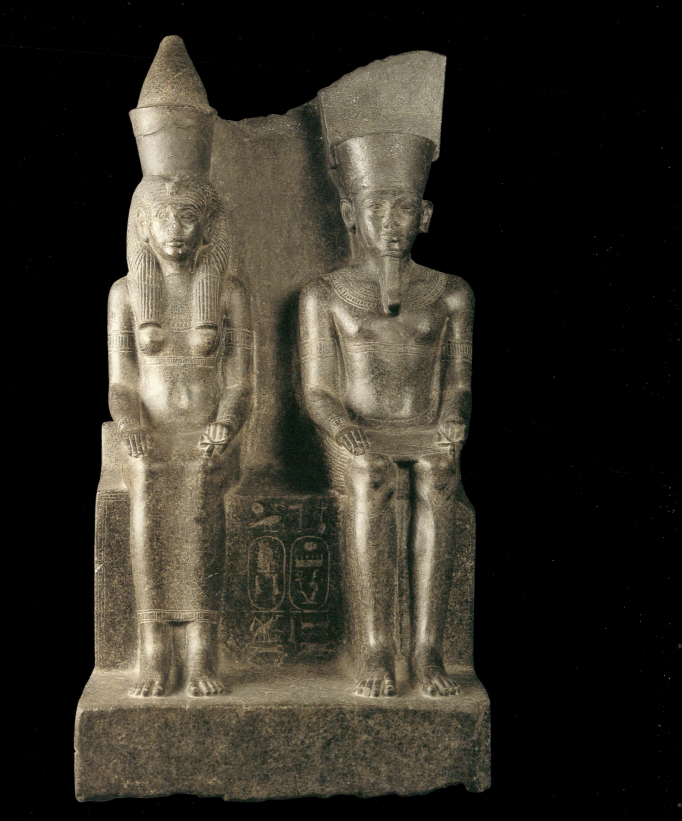

SEATED STATUE OF TUTHMOSIS III

Granite, 18th Dynasty, reign of Tuthmosis III 1504 - 1452 BC, Deir el Bahri, Gallery J

Found at the destroyed mortuary temple of Tuthmosis III in Deir el Bahri in 1965, this statue was carefully restored to its original beauty and went on exhibition in the museum in 2003. The king is sitting on his throne in the traditional pose, wearing the *nemes* (royal headdress), false beard and the *shendy* (royal kilt), with his cartouche inscribed on the buckle of his belt.

Here, Tuthmosis appears benevolent and the inscriptions mention him as 'the beloved of Amen, Lord of Thebes'. Although a mighty military leader, he was also known for his kindness: the vizier Rekhmire described the king as a father and mother to all of his people. Despite being largely preoccupied with military strategies and battles, Tuthmosis also interested himself in collecting rare flowers, birds and animals from conquered lands to bring back to Egypt, and many of them can be seen depicted on the walls of a room in Karnak, now called the 'Botanical Room'.

The first prophet of Amen, Menkheperresoneb, testified to the pharaoh's piety; that he spent his free time making small pots, vessels and statuettes, dedicating them to the temples of Amen. The inscriptions on the back of the statue state that Tuthmosis also dedicated it and some *nw* jars to the god Amen. This statue must have stood in one of the temples at Thebes before being moved and hidden in Deir el Medina.

The king's love of justice is illustrated in his maxims to his vizier Rekhmire, written on the walls of the latter's tomb in Qurnah, Western Thebes (TT 100). These were considered as forming the ultimate constitution for viziers, in so far as their dealings with the public were concerned. 'The god is fair, you have to stick to being fair'; 'Be alert in your tough job'; 'Listen to the one who comes to complain to you'; 'The god hates inequality'; 'Be respectful so that people would respect you'; 'Stick to being righteous and you will be rewarded by success'. King Tuthmosis III died at the end of his fifty-third regnal year and was buried in a beautifully decorated rock-cut tomb in the Valley of the Kings (KV 34). His cartouche-shaped burial chamber is adorned with hieratic texts from the 'Book of the Emdouat', meaning 'that which is in the underworld'. The figures are rendered in a simple linear form.

The pharaoh also allowed his high officials and viziers to acquire wealth and build large tombs reflecting their status. The tomb of the noble Rekhmire in Qurnah (TT 100) was one example, and that of Tuthmosis' military lieutenant commander Amenemhab, who also constructed his in Qurnah (TT 85), was another. Puemre the second prophet of Amen, in addition, built an impressive tomb in Khokha in western Thebes (TT 39).

His mother Queen Isis was a minor wife or lesser queen of Tuthmosis II. To compensate for this disadvantage, Tuthmosis III related the tale of how a divine oracle had proclaimed him to be the rightful successor to his father Tuthmosis II, inscribing it on the walls at Karnak Temple. This text claimed that the god Amen had selected him as pharaoh. Tuthmosis III was at Karnak

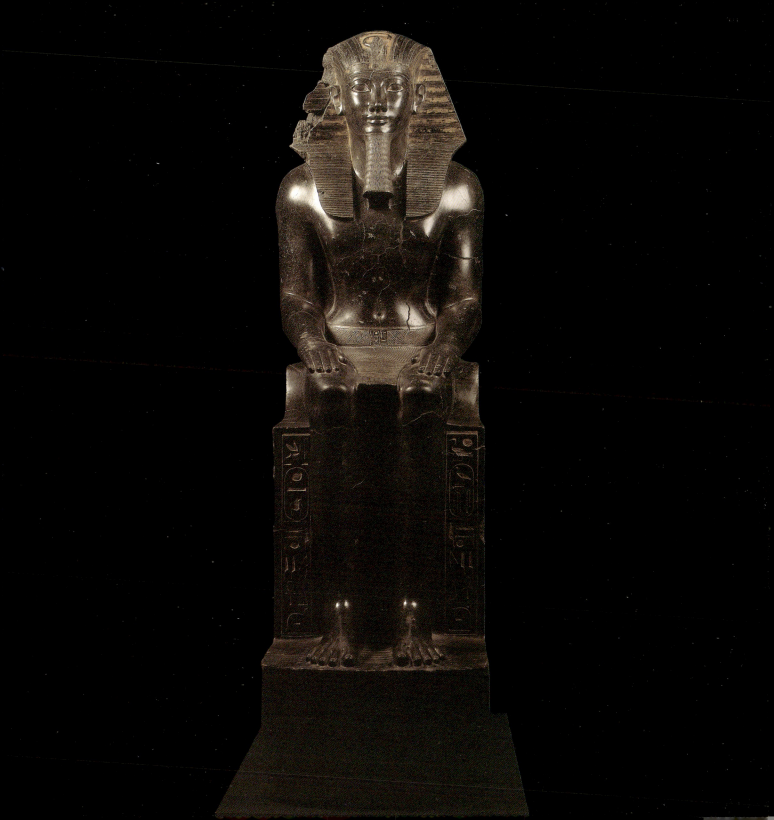

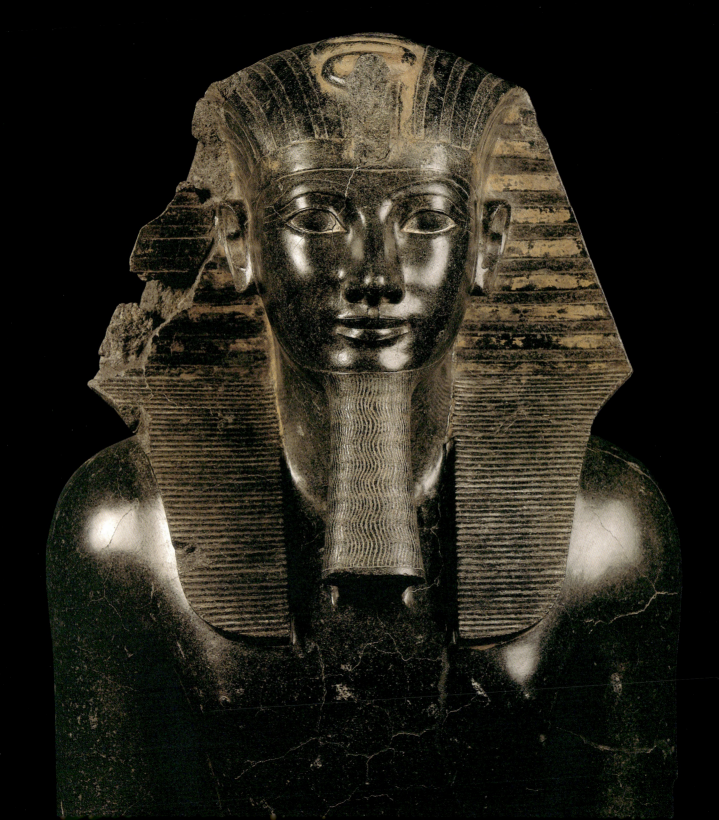

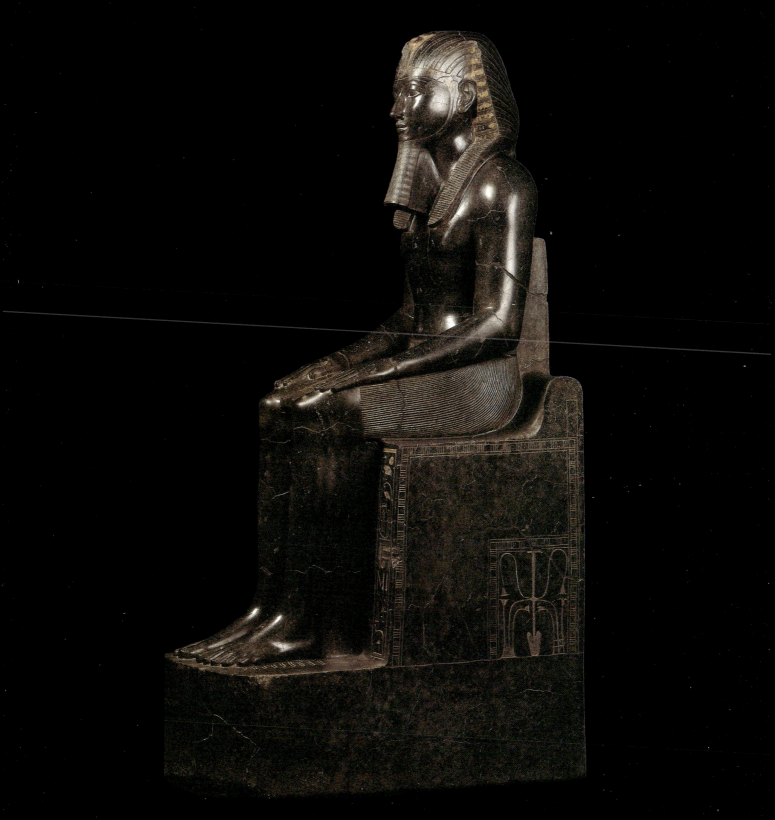

Temple during a religious festival when the procession of the divine barque of Amen accompanied by King Tuthmosis II was passing. Amen directed the procession to go to where Tuthmosis III stood, ordering it to halt in front of him. The priest considered this event as an expression of Amen's wish for the young Tuthmosis III to succeed his father. Subsequently, Tuthmosis III knelt to pray to give thanks to the god, and was led by the priests towards the coronation dais and crowned as the future king of Egypt. Tuthmosis III recorded this story, probably assisted by his father, to legitimise Tuthmosis III as his rightful heir, despite his mother being only a minor wife.

VICTORY STELA OF KAMOSE

Limestone, 17th Dynasty, reign of King Kamose 1571 - 1569 BC, Karnak, H. 231 cm, W. 109 cm, Gallery J

This is one of two stelae erected at Karnak by King Kamose, son of King Sekenenre; the latter initiated the wars against the Hyksos occupying the country during the 17th Dynasty. It is inscribed on limestone and the lunette shows the winged solar disc symbolizing victory and protection; the thirty-eight registers cite the victory of King Kamose over the Hyksos, attesting to that phase of the war. In the third year of his reign he set out with a powerful army composed of Egyptians and Nubians to travel northwards, where he overcame the Hyksos in the provinces of central Egypt and assumed control. Kamose returned to Thebes where he was received in triumph and honoured as a victorious king. This victory was not decisive and final; it was his brother Ahmose who was destined to resume the war of liberation against the Hyksos and finally free Egypt from their occupation.

MUMMY OF KING AHMOSE

18th Dynasty, Gallery K

The mummy of King Ahmose was discovered among those that had been transferred to the Deir el-Bahri Cachette in the 21st Dynasty.

Ahmose's decisive steps to drive the Hyksos out of northern Egypt at length succeeded, and he thus completed the task begun by his father and brother. His major attack was on Avaris, the Hyksos capital. When the city fell he pursued the remaining Hyksos to what is now Sharuhin in southern Palestine, where he laid siege to them for three years, eventually subduing the city. King Kamose and King Ahmose were the offspring of King Skenenra Taa II and Ahhotep, his queen consort. When King Kamose died during the struggle against the Hyksos, Ahmose ascended to the throne. As he was still a boy, probably only about ten years old, his mother Queen Ahhotep acted as regent until he was sixteen. When she died, King Ahmose honoured her by placing some very fine funerary jewellery in her tomb including an extraordinarily beautiful necklace with three pendants in the form of flies, which was the order of valour usually given to the commander of a victorious army. Such a tribute affirms the role the queen played. King Ahmose also placed his axe, which was decorated with scenes of his victory over the Hyksos in her coffin, as well as his dagger, as another gift to her.

Examination of his mummy revealed that he was about thirty-five years old at the time of his death.

Queen Ahmose Nefertary, the wife of Ahmose was also involved in the state's religious life as second priestess of Amen and she was named *hemet ntr*, which gave her great political and religious prestige, in addition to personal wealth.

The military expeditions and victories of Ahmose were recorded in the autobiographies of two professional soldiers: Ahmose, son of Abana, who was an admiral in the Egyptian navy and Ahmose Pennekhbet, who originated in Nekheb, now al-Kab near Edfu. These two soldiers gave accounts of the expeditions in which they took part, as well as the rewards they received for their bravery. Their diaries manifest the great respect they had for Ahmose.

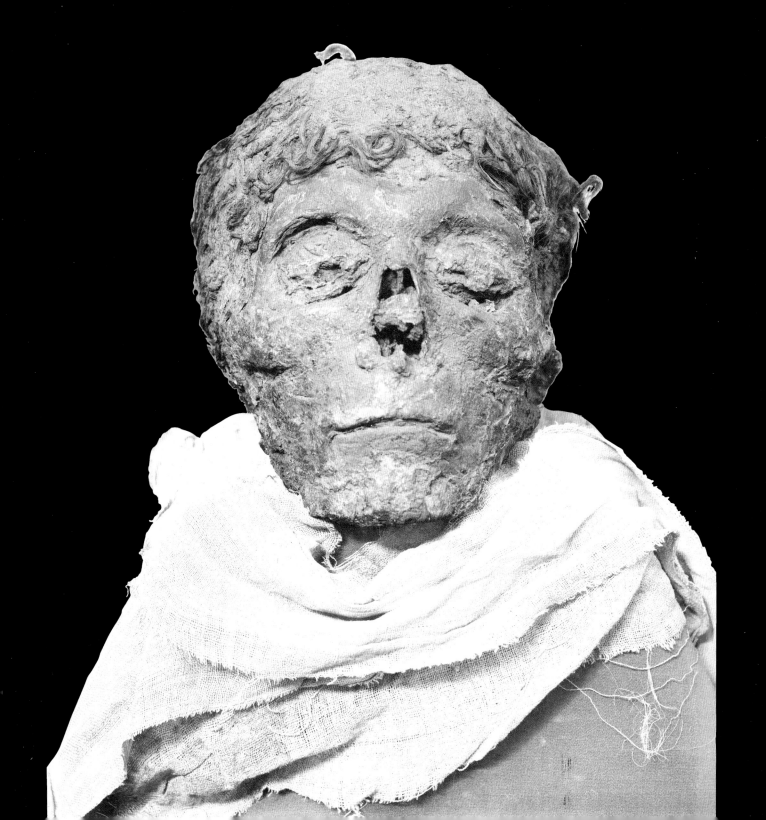

KING AMENHOTEP II AS AN ARCHER

Pink granite, 18th Dynasty, reign of Amenhotep II 1454 - 1419 BC, Karnak, Gallery J

This inscribed tablet was discovered in Karnak being used as a filling block in the third pylon. King Amenhotep II is depicted standing in a chariot pulled by galloping horses, holding his bow and shooting arrows at a copper target. Beside the chariot we see another practice target pierced by four arrows and the text: 'his arrows pass through as if the target were made of papyrus'.

Amenhotep II Akheperure was given an upbringing that involved special sports and military training under his father Tuthmosis III. King Amenhotep II later became well-known for his physical strength and skills as a charioteer, huntsman and archer. Many stelae relating his victories in Western Asia and Nubia have been found in Memphis, Karnak, Giza and Medamud, boasting of the king's abilities and accomplishments. The stories on them exaggerated his physical power, courage and strength, in contrast to the modest and analytical description of events registered in the annals of his father on the walls of Karnak Temple. He brought back seven captives from one campaign, to hang them from the gates of Thebes and the walls of the city of Napata in Nubia. His name was also found in the temple of Hathor at Sarabit el Khadem in Sinai. In addition, faience apes bearing his cartouche have been found in Mycenae (Greece).

Following in his father's footsteps, he placed stelae at Naharina on the Euphrates River and in Nubia, thus confirming Egyptian authority over those borders.

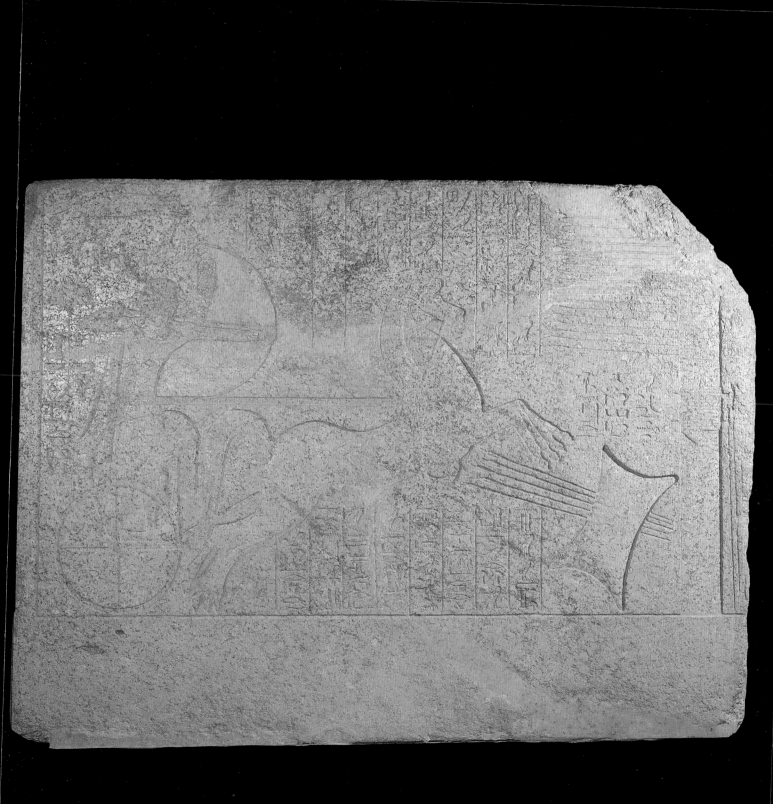

STATUE OF KING AMENHOTEP II

Pink granite, 18th Dynasty, reign of Amenhotep II 1454 - 1419 BC, Karnak, Gallery J

The statue of King Amenhotep II was discovered in Karnak in 1951. The king is wearing the *sekhmty* the double crown of Upper and Lower Egypt, with the protective royal cobra on his forehead and a false beard. Originally this statue was probably in a seated position.

Son of the royal consort Merit re Hatshepsut, Amenhotep was born in Memphis, where he spent his early years. His father Tuthmosis III entrusted his chief archer Amenmose with the boy's upbringing and military training.

King Amenhotep II was married to Queen Tia, the mother of his son and heir King Tuthmosis IV. He was buried in the Valley of the Kings (KV 35), where his mummy was discovered still in its sarcophagus, after being reburied in the late New Kingdom when this tomb was used as a 'cachette' for the royal mummies.

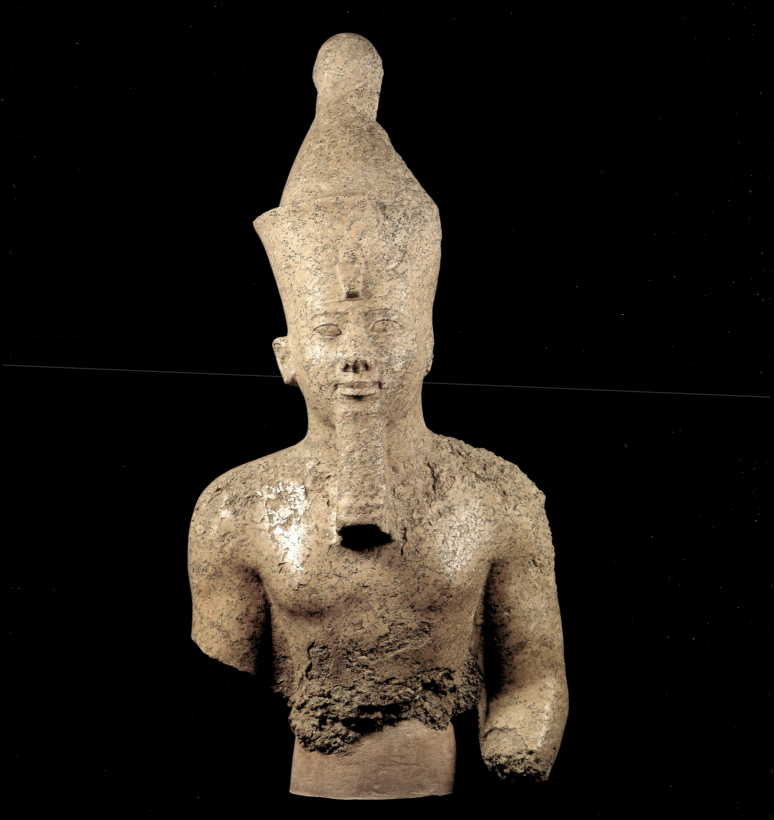

STATUE OF RAMSSES II

Red and grey granite, 19th Dynasty, reign of Ramsses II 1304 - 1237 BC, unknown provenance, Gallery J

King Ramsses II is wearing the *sekhmty* the double crown of Upper and Lower Egypt in this remarkable statue, which was carved from a single piece of granite, composed of red and grey sections. This granite came from one special quarry, where the unusual stone was found.

As the most celebrated and mightiest king of the Ramesside era, Ramsses II is often referred to as Ramsses the Great. In the fifth year of his reign, the king waged war against the Hittite King Muwatallis and his allies. Intending to attack the Hittites, who were garrisoned in a fortress in the city of Kadesh in Syria, the king split one part of his army into four groups, which travelled through the desert towards the Dead Sea, while a second sailed to disembark at a landing place north of Byblos in Lebanon. The four groups of the first army marched six miles apart, so there was no communication between them. When Ramsses reached the river, only one group crossed with him as the other three were still behind. The Hittites sent two spies, who told the king that the Hittites had withdrawn in fear of the Egyptian army. The king mistakenly believed them and advanced without taking any precautions. Suddenly, a thousand Hittite charioteers attacked. Ramsses managed to retrieve the situation and after claiming victory on the first day of battle, withdrew to higher ground and built a camp there, where subsequently he received the support of the second army that had travelled by boat.

The Hittites then retreated in the direction of Kadesh, and thanks to their ill-disciplined army, the king was able to return to Egypt with his troops, announcing a victory. He later recorded the scenes of this battle on the walls of temples, erected during his reign. Accounts were also written on papyri. Mistaken as poetry at first, the whole text is preserved on the papyrus 'Chester Beatty III', and another version exists on the papyrus 'Raife and Sallier III'.

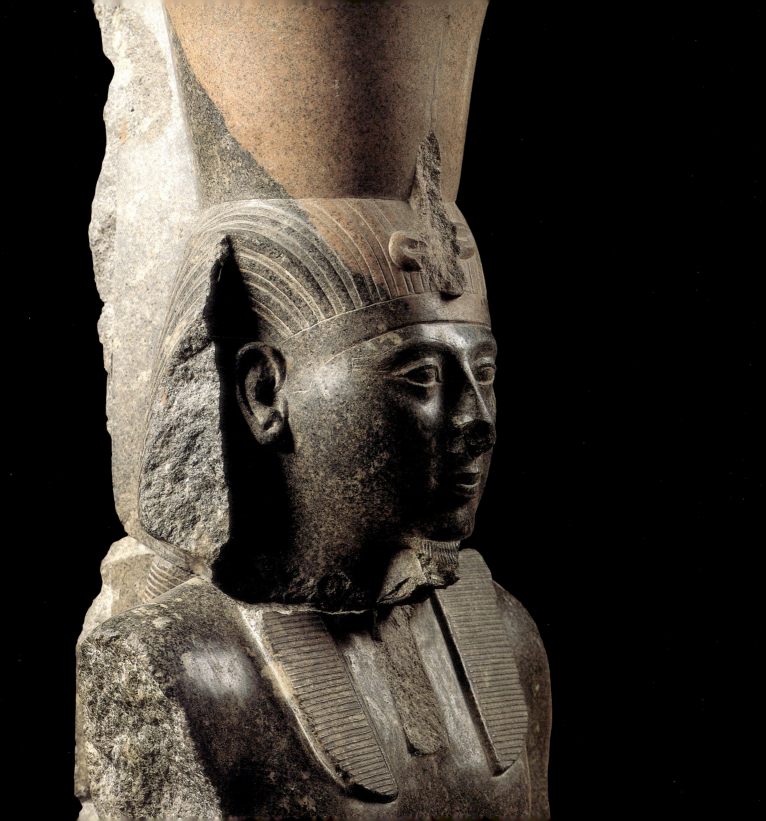

Later, as both sides realised that a complete military victory could never be achieved, they signed a peace treaty that ended hostilities between them.

He had two principal queens, Nefertary and Isetnofret. In addition, he married three of his daughters and two Hittite princesses. In all, he had about fifty sons and fifty four daughters. Many of his sons had military, civil administrative or priestly careers.

His mummy, which was taken to Paris in 1976 for precise investigation and conservation, is now in the Egyptian Museum. King Ramsses II had his own rock-cut tomb (KV 7) in the Valley of the Kings, and had tunnels for the tombs and burial chambers of his sons (KV 5) cut close to his, so that they would be buried nearby and resurrected with him in the realm of the hereafter.

This king's magnificent rule lasted for 67 years, and it was a reign marked by both great political events and enduring monuments. His colossal temple at Abu Simbel is one of the great highlights of ancient Egyptian architecture today.

On the west bank of the Nile, Ramsses constructed his memorial temple, the Ramesseum, as well as building a shrine for the Queen Mother Tuya. In addition, he built several tombs for his wives in the Valley of the Queens.

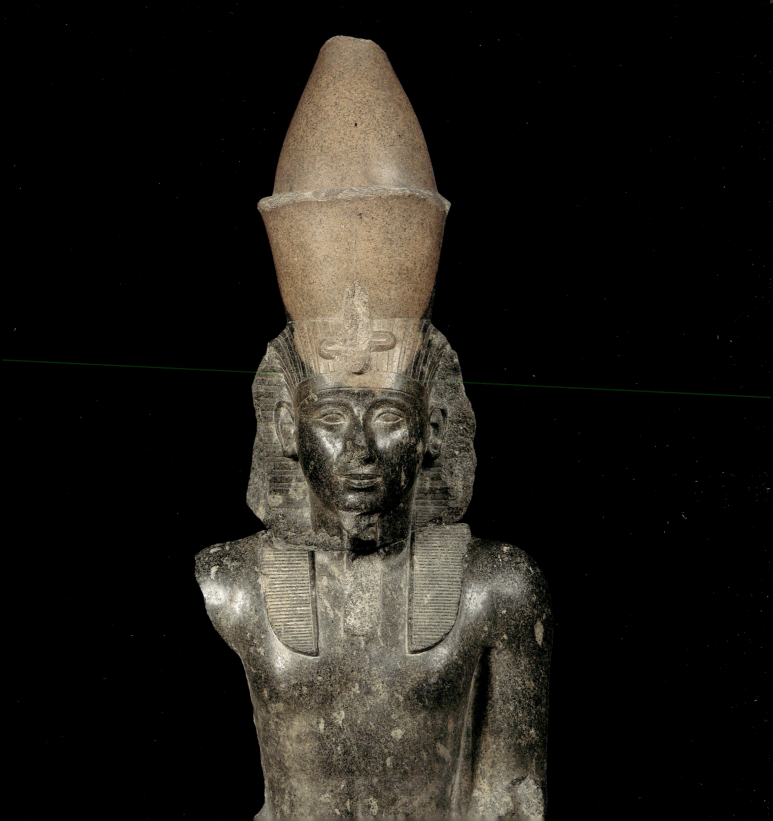

KING SETI I

Alabaster, 19th Dynasty, reign of Seti I 1314 - 1304 BC, Karnak Temple Cachette, Gallery J

This alabaster statue of King Seti I was discovered in the Karnak Temple Cachette. It is an example of a composite statue comprising several separate pieces attached together. It has lost several parts such as the *nemes* (royal headdress), the crown, the eyes and eyebrows, the false beard and the royal seals he held in his hands. Probably, those missing parts were made of precious materials that were stolen long ago.

King Seti I, the second 19th Dynasty ruler was a great solider pharaoh as well as an intrepid builder. In his third regnal year he defeated the Libyans who had invaded the west of the country. In the battle scenes shown on the outer northern wall of the Hypostyle Hall at Karnak, the king recorded his victories in Western Asia as well as in Nubia, where he crushed a rebellion in his eighth year of rule.

The mummy of Seti I, now in the Egyptian Museum, is one of the best-preserved royal mummies of the New Kingdom period, due to the exemplary embalming techniques prevailing at the time.

Seti I, who constructed magnificent monuments to the state gods like Amen-Re, Ptah and Osiris, also boasted the largest and most beautiful of all the New Kingdom tombs in the Valley of the Kings (KV 17).

The tomb of Seti I was restored during the sixth year of the reign of King Herihor in the 21st Dynasty. In the sixteenth year of this king's rule, the mummy of Seti I was moved to the tomb of a princess, before eventually being transported by King Panedjem I to the tomb of Amenhotep II. Finally it became part of the 'cachette' at Deir el Bahri.

In addition, he erected a splendid sandstone temple on the northern side of the necropolis in Qurna, to serve as a resting place and a way station for the procession of the god Amen when it came from Karnak during the Festival of the Valley. It was one of the temples to the west of Thebes, which bore the designation 'the house of millions of years', in the hope that it would endure forever.

At Abydos, Seti I constructed a magnificent temple to the god Osiris, together with a cenotaph tomb called the Osirion. He left a rich and flourishing empire to his son Ramsses II.

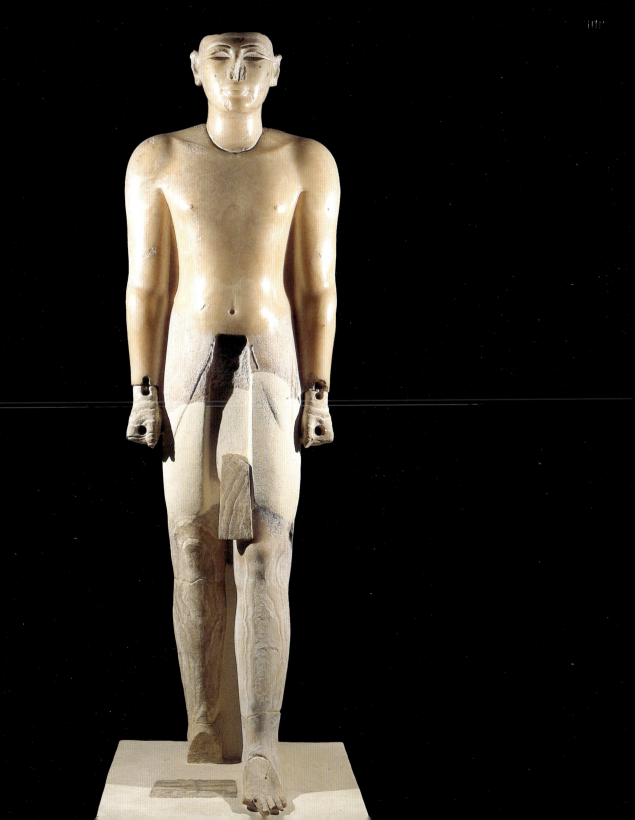

STATUE OF NEB-RE

Sandstone, 19th Dynasty 1315 - 1201 BC, Zawiet Um el-Rekhem, Marsa Matruh, Gallery N

The statue of Neb-Re was found in north western Egypt in Zawiet Um el-Rekhem near Marsa Matruh, at one of the forts built to protect the western border from the Libyans. Neb-Re, who was the commander of this stronghold under Ramsses II, is shown standing advancing his left leg forward. He is wearing a short layered wig, a multi-tiered *shebyu* collar necklace that was a special royal gift to grandees and people of distinction, signifying the exceptional qualities of the wearer. He is garbed in a long robe with short pleated sleeves and a pleated kilt. He holds his staff of office topped by the head of the lioness goddess of war Sekhmet. Her name meant 'the mighty one' and was derived from the word *sekhem*, which meant power. Her many other titles included: *wrt hekaw,* 'the great of magic'; *nbt srdjwt*, 'the lady of terror' and *nbt irt*', 'the lady of action'. Sekhmet was also one of the manifestations of the fiery eye of Re. A member of the Memphite triad, she was wife of Ptah and mother of Nefertum.

Throughout the history of Egypt a variety of fortresses and garrisons were constructed to protect the frontiers, control trade and the movements of people, as well as to cater for the Egyptian army while in transit.

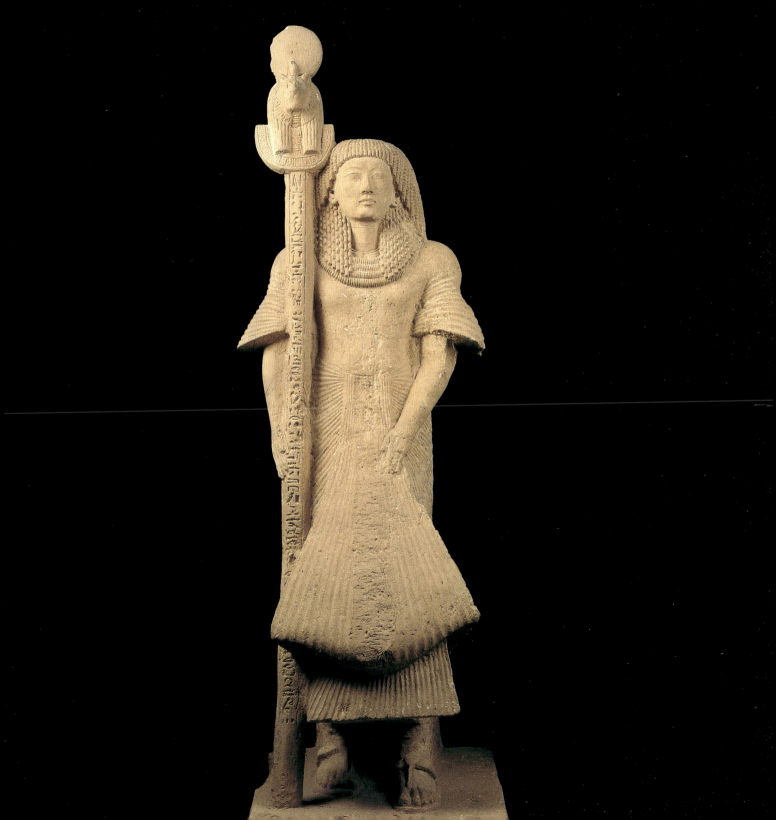

STATUE OF KING RAMSSES VI

Grey granite, 20th Dynasty, reign of King Ramsses VI 1156 - 1149 BC, Karnak Temple Cachette, Gallery N

This granite image of Ramsses VI was found in the Karnak Temple Cachette. It shows the victorious pharaoh grasping his enemy by the hair, with the latter bowing down before him, symbolizing humiliation and his submission to the triumphant king.

Judging by the hairstyle, the captured enemy seems to have been from Libya. The king is holding an axe in his right hand and his trained lion is standing beside him, adding an air of strength and power to the dominant pharaoh.

Ramsses VI, the son of Ramsses III and his queen Isis, completed the tomb begun by Ramsses V in the Valley of the Kings (KV 9) for himself. The position of this tomb was fortuitous, for it was the main reason why the entrance to the tomb of Tutankhamun remained hidden for so long and thus escaped desecration. Ramsses VI was the last sovereign whose name is to be found engraved in mines and quarry sites in Sinai, and it was during his reign that the viceroy of Nubia, Penny, constructed his fine tomb at Aniba.

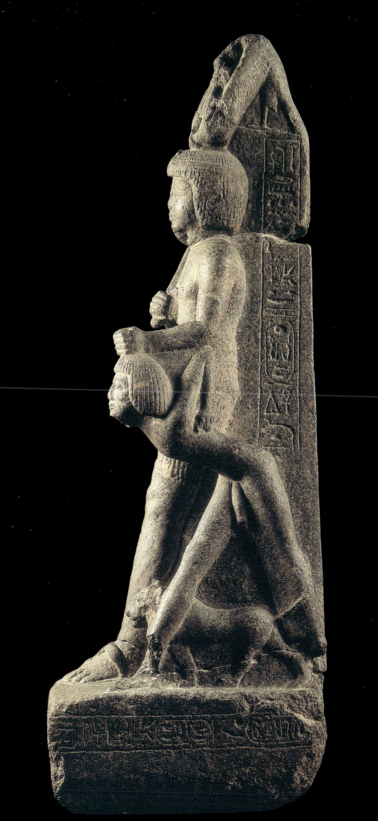

STATUE OF A PRISONER

Gray granite, Kasr el Kuba, Cairo, Gallery N

This statue sculpted as a monolithic piece shows a prisoner kneeling with his face on the ground and his arms tied behind his back. Judging from his facial features and the style of his hair and beard, he appears to have been from Syria-Palestine. This pose illustrated subjugation, humiliation and complete defeat. The presence of enemies and prisoners was frequently depicted in Egyptian art. As early as the 1st Dynasty, the picture of the pharaoh smiting his foes was the traditional pose of the victorious monarch, and symbolised his defeat of both the enemies of the country and the evil powers that could cause cosmic disorder in the world. On the bases of many royal statues, the king is shown stepping over nine bows representing the traditional enemies of Egypt. In addition, on the footstools placed near the royal thrones, we also see the nine enemies of the country portrayed; with Syrian, Nubian and Libyan facial features replacing the traditional metaphor of the nine bows.

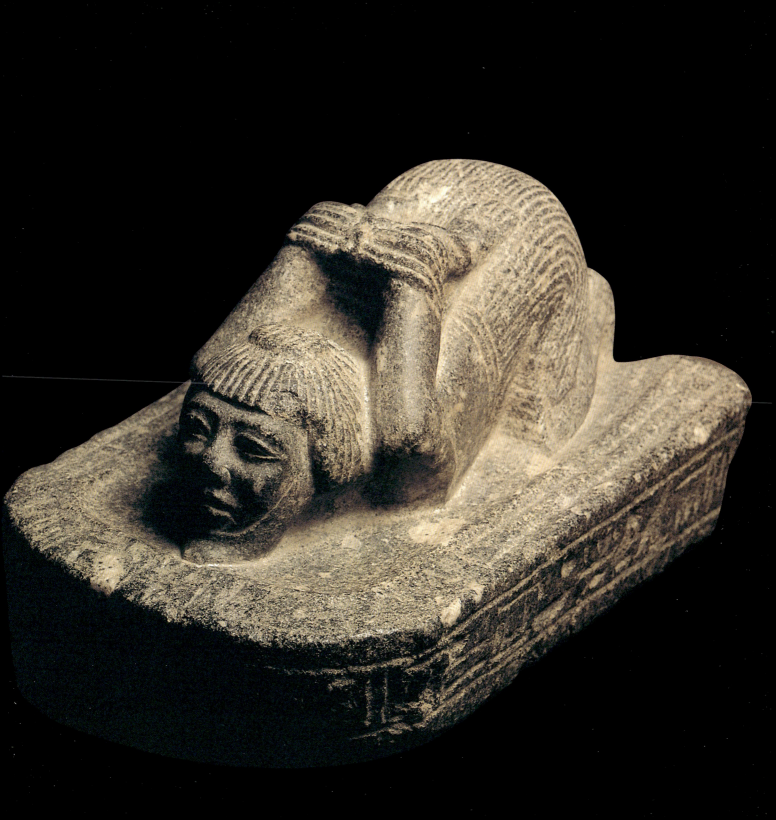

THE LIONESS GODDESS SEKHMET

Black granite, 18th Dynasty, reign of King Amenhotep III 1410 - 1372 BC, Karnak, Gallery O

This black head of the lioness goddess Sekhmet is one of dozens of such colossal, larger than life-size statues produced during the New Kingdom. Some six hundred like this are thought to have been placed in the Mut Temple at Karnak by Amenhotep III, probably in an attempt to improve his ill health. Sekhmet was one of the healing goddesses, who wielded special power being well versed in magic.

Sekhmet was represented as a lion-headed woman with a solar disc on her head and a cobra on her forehead,

Lions were viewed as supernatural guardian figures and many other goddesses were often depicted as lionesses; such as Pakhet, Tefnut, Hathor, Bastet and Mut. The two lion gods called Akrm were identified with the eastern and western horizons, between them supposedly supporting the rising of the sun. They represented 'yesterday and tomorrow', thereby symbolising eternity.

Ancient Egyptian divinities were represented in four different forms: as animal figures, human figures, humans with animal heads or animals with human heads. Some of the statues of divinities were cult statues, while others were votive given to temples by kings, courtiers and priests, in the hope of receiving benefaction from the god. One of their other roles was as guardian figures made for specific locations within a temple. Some statues of divinities were made extremely small so as to be used as amulets or personal charms. In addition, other statues were incorporated into pillars and columns to form an architectural element of a temple.

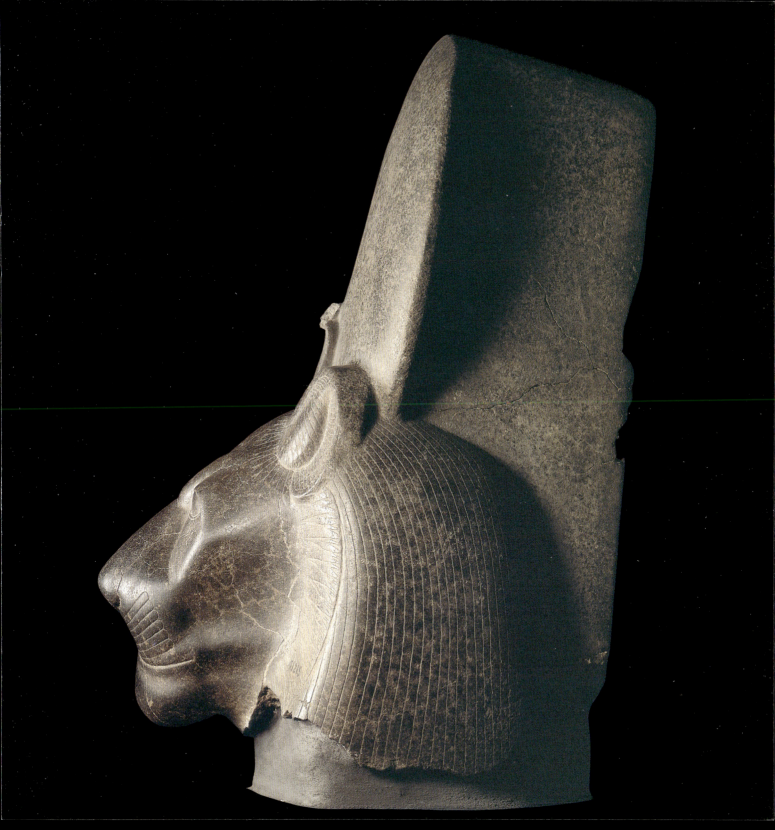

AMENHOTEP, SON OF HAPU

Granite, 18th Dynasty, reign of Amenhotep III, 1410 - 1372 BC, Karnak, H. 130.5 cm, Gallery O

Found in Karnak Temple in front of the tenth pylon in 1913, this statue belonged to Amenhotep, son of Hapu, a famous courtier who lived during the reign of King Amenhotep III. He is sitting in the cross-legged pose of a scribe and writing on a papyrus roll spread across his lap. He is wearing a short layered wig and appears in the prime of life with rolls of fat over his stomach, an indicator of his wealth.

This highly esteemed nobleman held several offices including 'royal scribe under the king's immediate supervision'. Other titles were 'royal scribe at the head of the recruits', suggesting his expertise in organisation and calculation; and 'chief of all the king's works' due to his talent for supervising large-scale works such as building projects and colossal statues. Proud of his knowledge, the scribe claimed to know the secrets of Thot, the god of wisdom and writing; and people consulted him in times of need. His mother was honoured, deified and associated with Seshat, the goddess of writing and calculation.

Amenhotep, son of Hapu was very close to the king, also acting as steward to his daughter Setamun. King Amenhotep heaped further honours on the scribe by allowing him to place statues of himself at Karnak. In addition, he built an impressive tomb in the necropolis, as well as a funerary temple among the royal temples on the west bank of the Nile at Thebes, again indicating his high favour with the king. During the Ptolemaic Period, Amenhotep, son of Hapu, was deified as a healing god and associated with the wise physician Imhotep, who was King Djoser's architect. The successful scribe was sometimes identified with the Greek Askelepios at this time, and a shrine was built to him at Deir el Bahri.

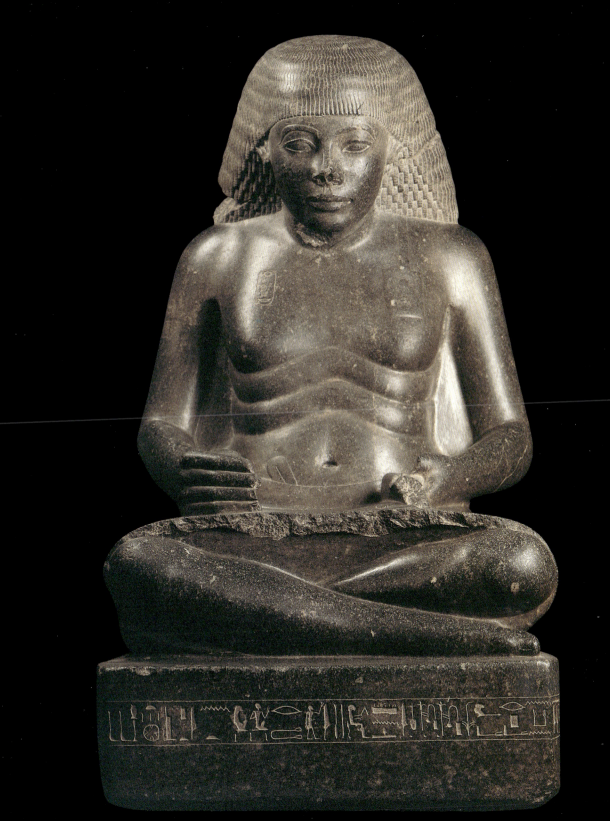

RELIEF OF A VICTORY PARADE

Sandstone, 18th Dynasty 1569 - 1315 BC, Karnak, Gallery O

This sandstone block discovered in Karnak, depicts a military parade with standard bearers followed by foot soldiers armed with shields, lances and swords.

The inscription is addressed to a ruler who won a victory in the land of Kush in Upper Nubia (North Sudan), and it goes as follows: 'You are like the god Montu in the midst of your army, the gods being the protection of your limbs, since you have repulsed him, who has arisen in the land of Kush'.

This likens the ruler to Montu, the falcon headed god of war, worshipped in the region of Thebes, in Armant in the south of Luxor, in Karnak and in El Tod, and el Medamoud, north of Luxor. In the Middle Kingdom, several pharaohs had Montu included in their names like Montuhotep meaning 'the god Montu is satisfied'. In the New Kingdom, he was overshadowed by Amen, but Montu remained a very important god as he represented the aggressive side of kingship and war. He became associated with the solar god Re as Montu-Re.

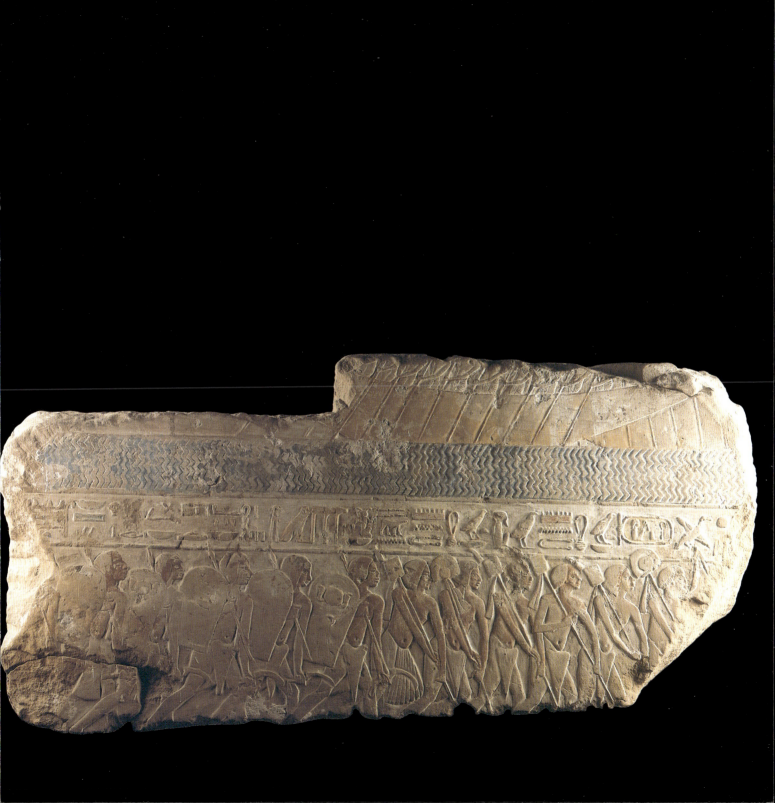

KING RAMSSES III

Greywacke, 20th Dynasty, reign of Ramsses III 1198 - 1166 BC, Karnak, Mut Pericnet, Gallery O.

This much damaged statue of Ramsses III was discovered in Karnak. The king is wearing the *sekhmty* double crown of Upper and Lower Egypt; a short wig covers his forehead embellished with a ribbon decorated with a cobra; the sides of the wig are also ornamented with cobras. The king is wearing a long starched, pleated kilt; in front of him the god Osiris is represented as a mummy.

Commencing building operations in the magnificent temple of Medinet Habu in the peaceful, early years of his reign; the pharaoh then shifted his attention to matters of defence. During his regnal years five to eleven, he fought off three attempted invasions; battling against the Libyans in year five. In year eight he won a great victory over the Proto-Hellenic 'sea-people'; then he warded off a second Libyan attack in year eleven.

The 'sea people' a group of distinct peoples of diverse origins advanced into Egypt by both land and sea, and the subsequent battles are illustrated in reliefs on the walls of the temple of Ramsses III in Medinet Habu. The 'sea people' were named the 'Sekelesh', and they are thought to have come from the island of Sicily; and included the Peleset from Palestine; the Denyen from Danaoi or mainland Greece, and the Sherden from Sardinia. The scenes show the Egyptian pharaoh with his army and navy winning an overwhelming victory. Some of the prisoners are women and children and are in chariots, signifying that they had intended to settle in Egypt.

At the end of his reign, certain officials conspired with one of the king's wives, Queen Tiye, to deprive the legitimate heir of the crown in favour of her son Pentawere. The plot failed, however, and the officials were caught and tried. Known as the 'Harem Conspiracy' and documented on the 'Harris Papyrus', this affair sheds light on the country's internal affairs at that time.

Ramsses III was buried in a magnificent tomb in the Valley of the Kings (KV11); though his mummy was later transferred to the royal mummy 'cachette' in Deir el Bahri. This monarch is considered the last significant king of the New Kingdom Period.

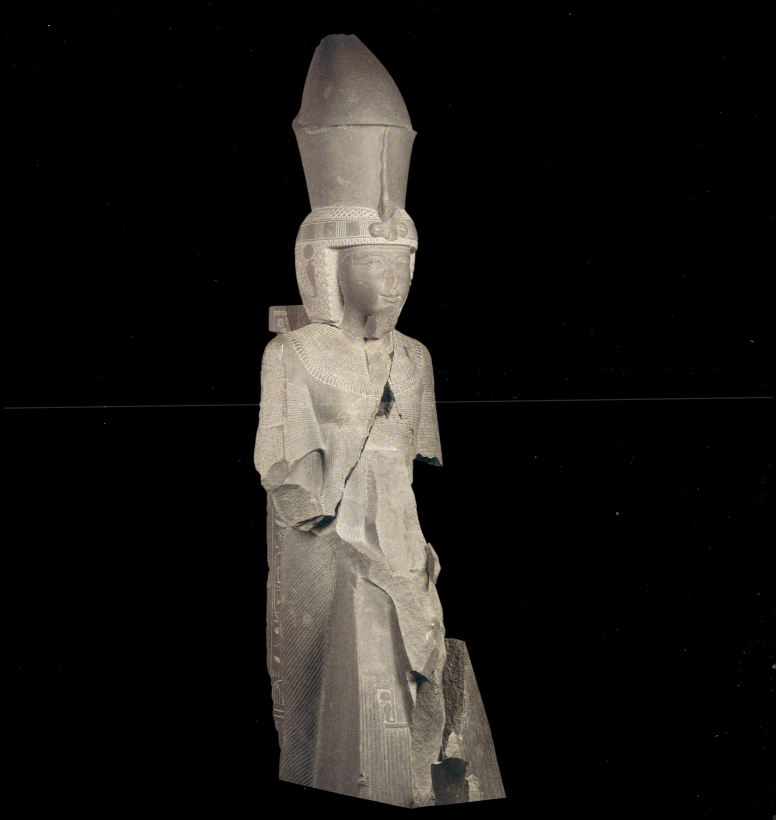

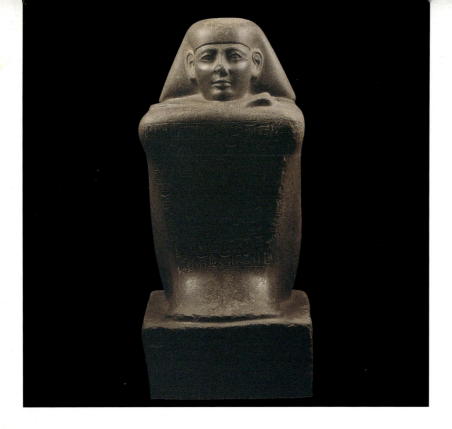

BLOCK STATUE OF YAMUNEDJEH

Grey granite, 17th Dynasty, reign of Tuthmosis III 1504 - 1452 BC, Qurna, H. 96.5 cm, Gallery O

The statue was found lying in front of the main entrance of the funerary temple of Tuthmosis III at Qurna, a site of the Theban Necropolis on the west side of the Nile. It is one of those sculptures carved in a cubic form known as 'block statues', which were popular from the Middle Kingdom period onwards.

It shows Yamunedjeh sitting with his knees in line with his chest and his arms resting on them. Such a pose offered a large surface for the lengthy inscriptions and texts that cover the entire statue. One such text mentions that Yamunedjeh accompanied King Tuthmosis III in the campaign of year 33 of his reign in crossing the Euphrates into Syria; he described the event as: 'I was behind his majesty to secure the borders of Egypt. Yamunedjeh's headdress covers his hair, leaving his ears exposed and he has a short false beard. He was a highly appreciated royal architect during the reign of King Tuthmosis III and well rewarded by the king, who permitted him to place his statue in the enclosure of the king's mortuary temple, thus having the honour of enabling his *ka* to enjoy the offerings presented there.

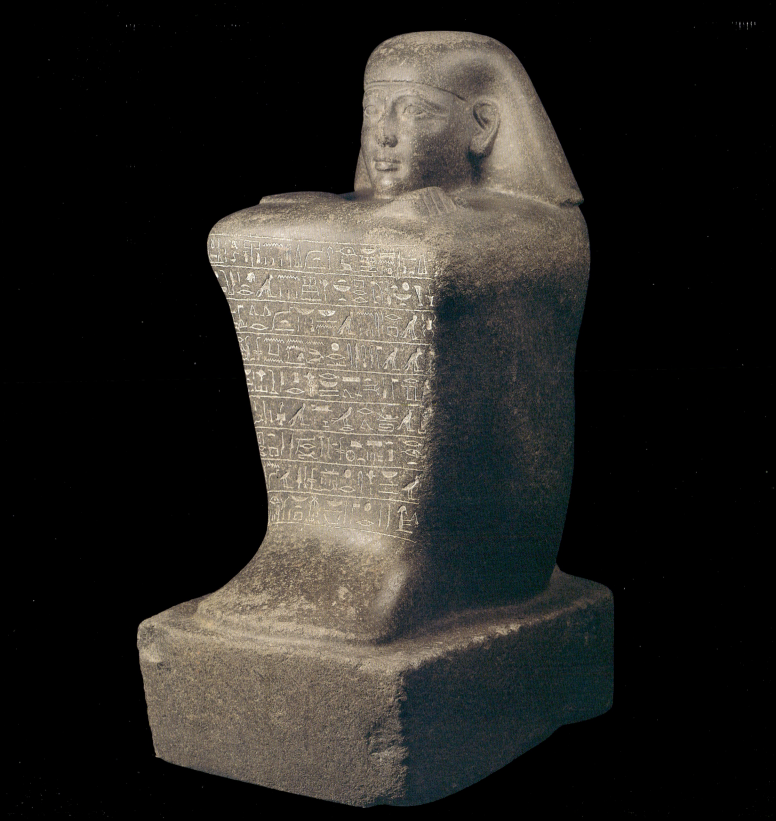

A NOBLEMAN WEARING THE 'GOLD OF HONOUR'

Painted sandstone, 18th Dynasty, reign of Amenhotep II or Tuthmosis IV 1454 - 1410 BC, Qua el-Kebir in Middle Egypt, H. 87 cm, Gallery O

This sculpture found on a site in Middle Egypt shows a nobleman standing in the traditional manner advancing his left leg forward. The statue rests on a base and has a large back support consolidating the whole of the monolithic piece.

He is wearing a straight wig and his features reflect both serenity and strength. He has a double-layered collar around his neck, two armlets and a bracelet on his right wrist. He is clothed in a long starched linen kilt. His reddish brown skin colour conforms to the tradition that depicted men with darker skin as if tanned by the sun. He is wearing an innovative tiered, collar necklace called the *shebyu,* which first made its appearance during the reign of Tuthmosis IV. Other examples can also be seen in the tombs of Khaemhat (TT 57) and Ramose (TT 55) in Qurnah, from the reign of Amenhotep III. The *shebyu* consisted of a series of necklaces formed by threaded disc shaped gold beads, and was a special royal gift to grandees and people of distinction, signifying the brilliant qualities of the wearer. The armbands he is wearing were also part of the award. It was particularly popular during the Amarna period of King Akhenaton. Probably the golden discs were regarded as solar symbols.

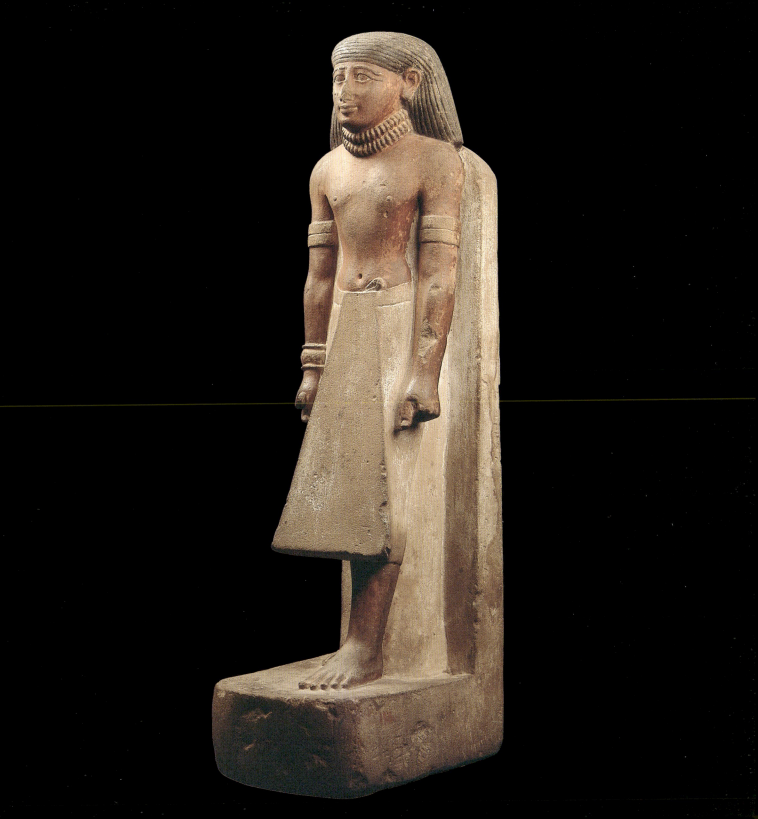

HATSHEPSUT REPRESENTED AS A WOMAN IN THE PRESENCE OF AMEN

Limestone, 18th Dynasty, reign of Queen Hatshepsut 1502 - 1482 BC, Karnak, Gallery F

This block is inscribed with a unique depiction of Queen Hatshepsut as a woman standing before the god Amen.

The upper part shows the winged solar disc representing victory and protection for the queen. On her head she has a composite crown of two feathers, a solar disc and two horns symbolizing the ram, which was the sacred animal of the god.

She is wearing a short, curly wig, a large *usekh* collar and a closefitting, transparent dress that reveals the contours of her body and her femininity. She is holding two *nw* jars and in the hieroglyphic text inscribed next to her, it states that she is offering milk to the god. Her name Maat Ka Re inscribed in the cartouche beside her head emphasizes her identity.

Although a woman, the queen was always represented as a male pharaoh with a reddish-brown skin, the traditional colour for men both on statues and in murals, wearing a beard and clothed in a pharaoh's robe. The texts refer to her as 'King of Upper and Lower Egypt', not as queen. She also had herself depicted as a sphinx to accentuate the impression of power, and to be seen as wise as a man and as strong as a lion.

There was sometimes an amalgamation between the male and female elements as in the following text: 'The King of Upper and Lower Egypt, the Lord of the Two Lands, Maetkare the daughter of the King, his beloved Khnemetamen Hatshepsut, to be given life forever and ever'. In this inscription, the queen used male titles and yet referred to herself as a woman. This characteristic also appeared in the literature of the period, as when one noble spoke of her as a male and a female at the same time: "I followed His Majesty, King of Upper and Lower Egypt on her journey". In addition, the chief of Punt, called Parehu and his fat wife Ati, when they saw the statue of Hatshepsut, they paid it the highest homage, calling her 'The great King of Egypt, the female shining sun'.

She was the daughter of King Tuthmosis I and his queen consort Ahmose. Hatshepsut ruled first as regent with Tuthmosis III, her stepson and son-in-law for a few years, before assuming full power and crowning herself as sole king of Egypt, taking the royal titles. To legitimize her rule, she related the story of a celestial birth, claiming to be the divine daughter of the god Amen. She proclaimed this story and had it illustrated on the walls of the northern colonnade, on the

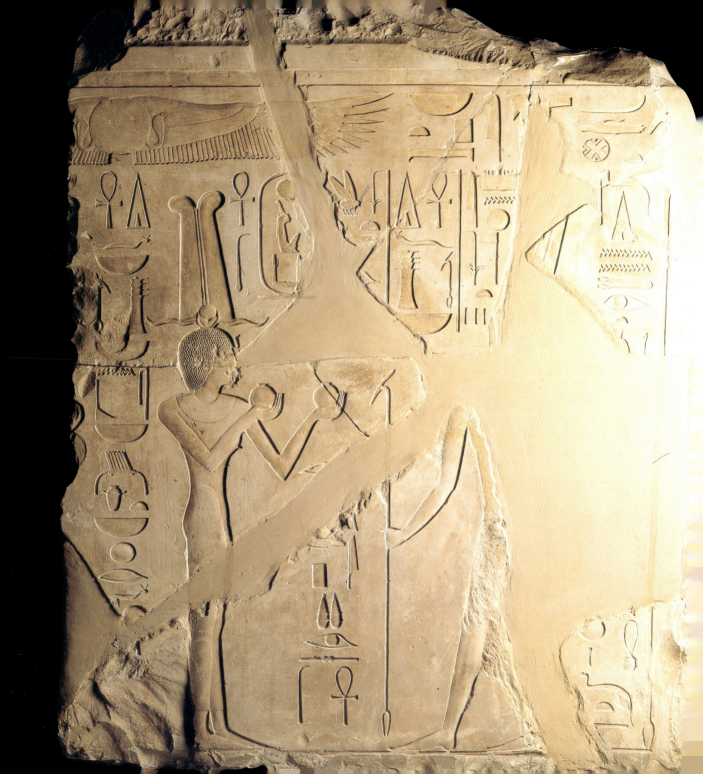

second terrace at her temple in Deir el Bahri. That scene shows the divine meeting between her mother Queen Ahmose and Amen, who sit facing each other, while the god extends a sign of life to the queen, symbolically impregnating her with the divine child. Next, they are raised to heaven by two goddesses, where the god Khnum shapes Hatshepsut and her royal *ka* on the potter's wheel. The pregnant queen is then led to the birthing room, where various gods record the divine birth. In the next section after the birth, her mother, Ahmose is seen receiving the congratulations of Amen, as her daughter Hatshepsut will be the ruling king of Egypt. Although a woman, Hatshepsut took on the outward appearance of a king.

Hatshepsut was not the first queen to rule Egypt as there were previous instances, but for shorter periods and without the great monuments or achievements of this queen. In the Turin Papyrus we read that at the end of the 6th Dynasty, a queen called Nitokris ruled Egypt for two years, and had the title Mn kaw re, 'stable are the doubles of re', but little is known about her reign. Then at the end of the 12th Dynasty, there was another queen, called Sobek Nefru, who ruled for four years.

One of her names was 'Maet ka re' meaning 'the justice of the *ka* or double of Re', which was the coronation name of Hatshepsut. The name Hatshepsut khenemet Imn was her birth name and meant 'the united one with Amen, the one who is in front of the noble ones'.

In spite of several military expeditions to Nubia, Syria and Palestine, her reign was a peaceful one and it was known as an era of extensive building activity. She built the red chapel at Karnak, which is now in the open-air museum. She also erected two obelisks in front of the fifth pylon at Karnak in the sixteenth year of her reign, which were cut from a monolithic granite block in the quarries at Aswan and transported to Karnak, all within seven months. The apexes were once covered with a mixture of gold and silver. The remaining whole obelisk weighs approximately 320 tons. This still stands at Karnak and is the tallest to be found in Egypt today. Only the upper part of the second has survived, and it now lies beside the sacred lake at Karnak. These obelisks were damaged, despite the wall built around them by Pharaoh Tuthmosis III, to hide the name of Hatshepsut that was inscribed on them. He did not destroy the obelisks out of respect for the god Amen-re, to whom they were dedicated. At the same time, this pharaoh defaced Hatshepsut's images and removed her name inserting his own instead.

Hatshepsut in addition, built the first rock-cut temple in Egypt. It lies in Estable Antar, a mile and a three-quarters south of Beni Hassan in Middle Egypt, and was dedicated to the goddesses Bakhet and Bastet, who were known to the Greeks as Speos and Artemidos. In this temple, a famous text declares how she devoted herself to repairing buildings that were damaged during the Hyksos invasion.

She built two tombs; the first when she was still 'the great wife' of Tuthmosis II is situated near the Valley of the Queens, where her first sarcophagus was found. The second is in the Valley

of the Kings, (KV 20), where her red quartz sarcophagus and canopic chest were discovered; together with the sarcophagus of her father Tuthmosis I. Her mummy was not found.

Hatshepsut's successor, Tuthmosis III defaced her statues and eradicated her name. The queen's name was also omitted from the lists of kings compiled later, such as the Abydos List from the reign of Seti I.

Many of Hatshepsut's high officials had their tombs in the Theban necropolis; Senmut was one of the most influential among them. He was the royal architect of Hatshepsut's mortuary temple, and was also believed to have been her lover and leading follower.

HEAD OF KING AMENHOTEP I

Sandstone, 18th Dynasty, reign of King Amenhotep I 1545 - 1525 BC, Karnak, H. 58 cm, Gallery F

Found in Karnak, this sculpted head shows king Amenhotep I wearing the *hedjet* white crown of Upper Egypt, the royal cobra on his forehead symbolizing protection and a false beard.

Amenhotep I inherited a strong and peaceful country and continued to consolidate and strengthen it during his rule, which lasted for 20 years. Admiral Ahmose, son of Abana, who had served in the campaigns of King Ahmose accompanied Amenhotep I on an expedition to Lower Nubia to secure the border and reincorporate the area between the First and Third cataracts into the empire; recording the events in his diary. The pharaoh established an administrative centre at the Second Cataract fort at Buhen, creating the new post of viceroy of Nubia. Thus Egyptian control of the trade route to Africa was reaffirmed.

Among Amenhotep I's great building activities was the construction of the alabaster chapel in Karnak, called 'Amen with enduring monuments'. At Deir al-Bahri and Draa Abu al-Naga, he built boat chapels for the divine god Amen; at al-Kab he built a temple for the goddess Nekhbet. He constructed the artisans' village attached to the Theban necropolis at Deir al-Medina, where he was venerated and deified. Feasts were held in his honour throughout the year, and he was represented in three forms: 'Amenhotep of the forecourt', 'Amenhotep beloved of Amen' and 'Amenhotep of the town'.

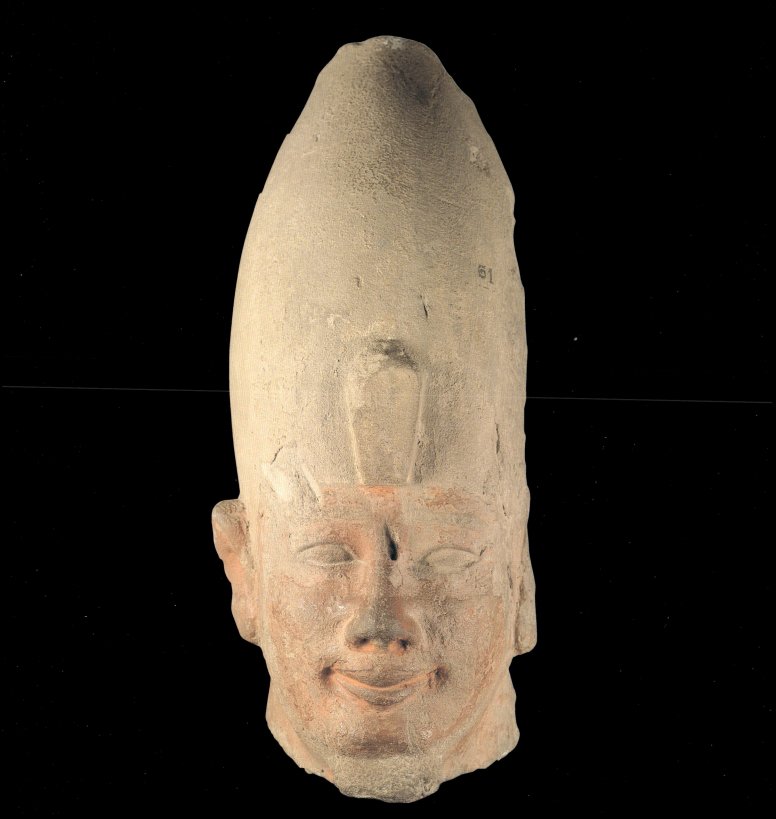

HEAD OF AKHENATEN

Sandstone, 18th Dynasty, reign of Akhenaten, 1372 - 1355 BC, Karnak, H. 141 cm, Gallery H

This sandstone head of King Akhenaten was also found in Karnak, in the temple that Akhenaten built for the god Aten. This was situated outside the enclosure wall to the east of the great temple of Amen, when Thebes was witnessing the gradual appearance of the new religious reform. The name of the temple was *Gempaaten*, meaning 'the Aten is found'. Some twenty-eight pillars stood in the temple's courtyard supporting colossal statues of the king, 6 yards high. This head is one of two in Luxor Museum; four are in the Egyptian Museum in Cairo, one in the Louvre, another in the Munich Museum, and the rest are in the storerooms at Karnak and the Egyptian Museum.

He is wearing the *sekhmty* double crown of Upper and Lower Egypt, and a royal protective cobra adorns his brow.

His peculiar face has slanting eyes, a long nose, thick lips, sunken cheeks and a drooping chin with a false beard. The face has the expression of a philosopher, although he has been dubbed by some Egyptologists and historians as 'the heretic king'.

The strangeness of the face and shape of the body has made Egyptologists question Akhenaten's physical health and wonder if he had a pathological deformity. On the other hand, the king may have wished to represent himself in a distinctive shape, unlike an ordinary human being, in order to stress the uniqueness of his religion of the god, the Aten. These greatly exaggerated features, characterising the early representations of the king, become more moderated in later years.

Akhenaten's religious reforms also had a political side aimed to counter the power of the wealthy and influential priesthood of Amen and to promote other cults. The encouragement of other sects had existed on a small scale during the reign of his father, but King Akhenaten's reforms were far more dramatic. Following the Amarna period, the adoption of other sects continued up to the reign of King Ramsses II who embraced the cults of Ptah and of Rehorakhty, again to limit the influence of the powerful priests of Amen-re.

The Aten was not new to the Egyptian pantheon but had always existed as only a minor god. In the Middle Kingdom period his name appeared in 'The Story of Sinuhe'. Aten was originally represented as a hawk-headed deity with a human body. The new cult of the Aten was actually established during the reign of Tuthmosis IV, but on a very small scale. The sect was promoted further by King Amenhotep III, who was entitled 'the dazzling sun disc', signifying the Aten. In addition, he applied the name Aten to some of the contents of his palace, and named the boat of his consort Queen Tiye, *Aten tehen*, 'the shining Aten', combining the old and new cults.

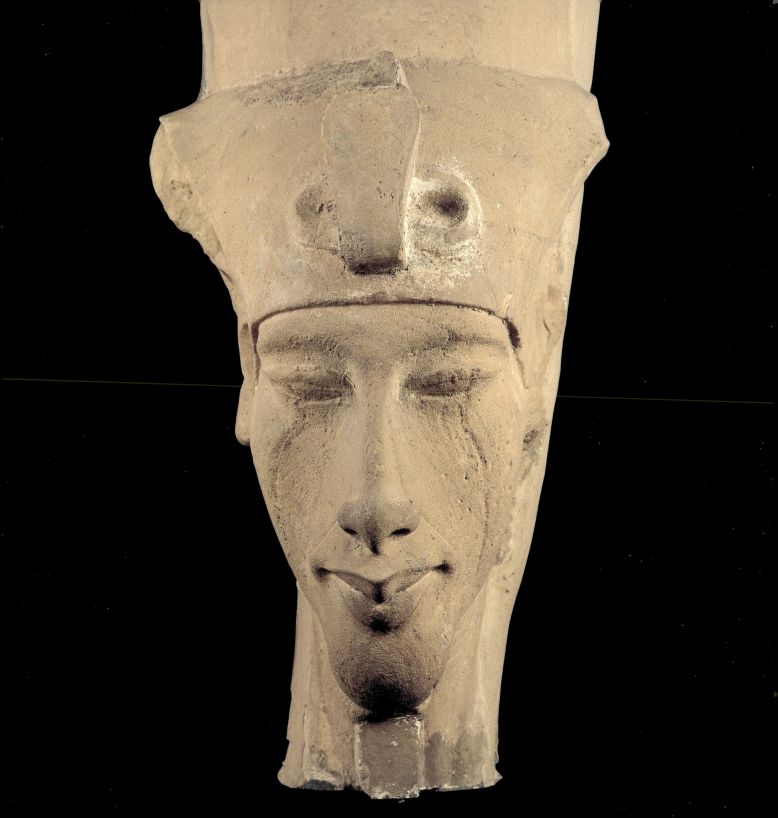

WALL DECORATION FROM AKHENATEN'S GEM PA ATEN TEMPLE

Sandstone, 18th Dynasty, reign of Akhenaten, 1372 - 1355 BC, Karnak, L. 17. 17 m, H. 2. 97 m, Gallery H

This is a restoration of several *Talaatat* blocks originally used to decorate the walls of the *Gem pa Aten*, the temple built by Akhenaten to the god Aten, in the east of Karnak. It shows scenes of the cult of the Aten, as well as some daily activities in the workshops and the temple of the Aten.

In his first regnal year King Akhenaten followed the cults of Amen-re and Rehorakhty, and bore the names Amenhotep Neferkheperure, 'Amen is satisfied, perfect are the forms of Re' and Waenra, 'the sole one of Re'.

In his second year he celebrated the *sed* festival and shortly thereafter ordered the construction of the temple of the Aten, to the east of Karnak. It was built of small-sized sandstone blocks that could easily be handled and transported from the Gebel el Selsela quarry to north of Aswan. The blocks of his temple were therefore simple for King Horemheb to later dismantle. The latter reused them to fill the core of his ninth pylon at Karnak, where twenty thousand were found. Another forty thousand blocks, were discovered beneath the hypostyle hall and the second pylon at Karnak. Those blocks are now being reconstructed, giving valuable clues to that historical period. This wall decoration comprises two hundred and thirty-eight pieces representing all aspects of activities of daily life at the time of Akhenaten.

Having decided to leave Thebes, the king started to build his new capital AkhetAten in his fourth regnal year at a site now known as Tell el Amarna. It covered an area of ten miles on the east bank of the Nile and the royal family moved there in the sixth year of his reign. Akhenaten constructed fifteen boundary stelae between his fifth and eighth regnal years; their inscriptions stated that the Aten had chosen this virgin area as it was untouched by previous cults. Before leaving Thebes, Akhenaton closed the temples of Amen and prohibited the sect, removing the god's name from the texts and monuments, together with that of his father. The king thereby put an end to the wealth and influence of the priesthood of Amen-re. He remained in Tell el Amarna for seventeen years, concentrating his efforts on practicing the cult of the Aten, until his death.

Akhenaten presented himself as the son of the Aten, whereas pharaohs since the 4th Dynasty had been the sons of Re. Akhenaten was the mediator between the god Aten and the rest of Egypt. He was the father and mother of the entire country, the highest priest of the Aten and the centre of

the cult. He was the only one who truly knew this god, so had appeared as his herald and prophet. He emphasised justice, together with the political, social and cosmic order of Maat, calling himself 'the one who lives in Maat'.

Akhenaten brought an end to polytheism and established monotheism. This change came about in stages, Akhenaten at first replaced Amen-re with the falcon-god Rehorakhty Aten. Finally, the Aten was represented simply as a solar disc with its radiating life-giving rays of light ending in human hands, appearing in front of the king and his wife. Although the word Aten meant the sun disc, The Aten was not the solar disc itself but the light emanating from it, to light up the world and give life to all.

BUST OF AKHENATEN

Sandstone, 18th Dynasty, reign of Akhenaten, 1372 - 1355 BC, Karnak, Gallery H

This bust was part of one of the twenty-eight statues of the king found in his temple *Gempaaten* in Karnak. He is wearing the *nemes* headdress with a cobra on his forehead. The face is depicted in the characteristic exaggerated style, with a long chin, v-shaped lips and elongated ears with pierced lobes.

His arms are crossed over his chest, and the king is holding the *heka* emblem of power and the *nekhekh* symbol of authority. He is represented with a thin neck, narrow shoulders, and a fleshy chest. Cartouches, containing the names of the god Aten, who is presented as the chief of the gods, are seen on both arms.

Akhenaten first called the god Aten, 'the father' and later, 'the king of the gods', placing these names in the royal cartouches and displaying the Aten disc along with a royal cobra. Another name was 'the god Aten represented as Rehorakhty, who rejoices to the horizon in his name that is Shu, the light residing in the solar disc'. The god Shu is present to show the religious connection with his father Amenhotep III, who was deified during his lifetime in the form of the creator god Atum. Accordingly, Akhenaten, when he was living in Thebes, was deified as the son of Atum, who was the god of air Shu. At the same time, Akhenaten's wife Nefertiti was deified as the goddess of humidity and water Tefnut, the wife of Shu.

The Aten was regarded as the unique creator god with all the divine qualities and power, while the king was his sole representative and prophet on earth. 'The Aten was the one, the light, the universal, the father, and the one who was within King Akhenaten.'

Statues of other kings attached to temple columns usually took the Osiride form with the arms crossed over the chest, and the body covered with mummy bandages. Here, the king has taken on a different shape, appropriate to his new religious philosophy and religious reforms, thereby creating a revolution in art. In ancient Egypt, art served both religion and the state. In some of the colossi of Akhenaten, he was represented as naked and asexual, to emphasise his uniqueness by combining the two powers of nature and being shown as both male and female.

After the death of Akhenaten, his statues were pulled down; his buildings in Tell el-Amarna were destroyed, and the stones reused. His name was eradicated. The servants and workers who still resided there reintroduced the worship of other gods; abandoning the city after Tutankhamun left for Thebes. Subsequently, the statues were destroyed and buried, and the city was used as a quarry for the Ramesside temple at Hermopolis.

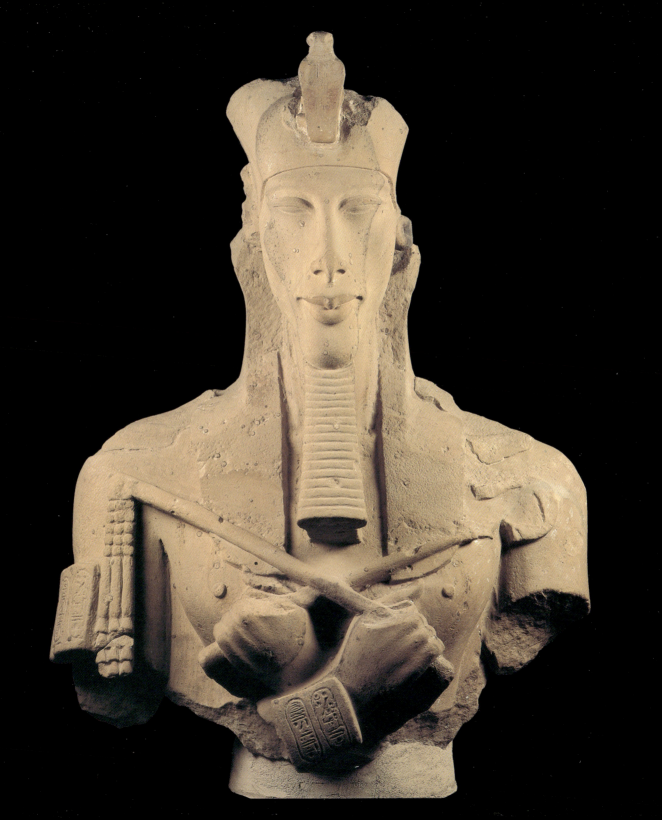

SENUSERT I AS OSIRIS

Limestone, 12th Dynasty, reign of Senusert I (1971- 1928 BC), Karnak. H. 157 cm, W. 106 cm, Gallery H

This limestone sculpture of King Senusert I was found attached to a column in Karnak.

It shows the king as a mummy; his body wrapped in white linen bandages is a metaphoric representation of Osiris, in the same posture placing the hands over the chest and holding the *ankh* sign of life in each hand. The king also has the curly false beard that appeared in representations of gods in the realm of the hereafter. His crown and the lower part of his body are lost.

Senusert I ruled for forty-two years in addition to ten years as co-regent with his father Amenemhet I. His name Sn-wsrt Kheper-ka-re meant 'the one who belongs to the goddess Wsrt, the form of the ka of the god Ra'. Although he lived at al-Lisht he paid great respect to Thebes and its god Amen, and in this god's great Karnak Temple he built a limestone chapel, called the white chapel; the glory of the temple and one of the most celebrated works of art from the Middle Kingdom. Senusert installed the chapel as a resting place for the divine boat of the god Amen, although some scholars think this might have been where the king celebrated his *sed* festival during which the pharaoh's power and kingship were confirmed and renewed.

At Iwn, later called Heliopolis and now known as Mataria or Ain Shams (the spring of the sun), thirteen miles northeast of Cairo and then the centre of worship of the creator sun god Atum, Senusert I erected two obelisks. One still stands today; it is twenty-four yards high and is the oldest obelisk preserved from ancient Egypt.

Senusert I was deified at Buhen, north of the Second Cataract, as the sovereign who extended the Egyptian empire to Nubia. During his reign Egypt exercised tight control over this southern region. Senusert appointed Egyptian governors as local rulers in Karma, the most important city in the vicinity of the Third Cataract and a major commercial centre. One of these governors was Hapydjefay, who originated from Assiut and carved a tomb, which is considered to be the largest rock–cut tomb from the Middle Kingdom in Assiut. He title was 'the supreme chief of the south and the head of the southern chieftains'.

One of the most famous pieces of literature from ancient Egypt is the Story of Sinuhe, which was composed during the reign of Senusert I. It tells the story of Sinuhe a devoted courtier, who accompanied Senusert on an expedition to the Western Desert, but was afraid of being incriminated in the assassination conspiracy against Amenemhet I, Senusert's father and co-regent. Although innocent, when Sinuhe learnt of the plot he fled Egypt, wandering the Eastern Desert and crossing the frontier first to Palestine and then Lebanon, where he stayed for many years. In his old age he asked for Senusert's pardon, and eventually was allowed back into Egypt.

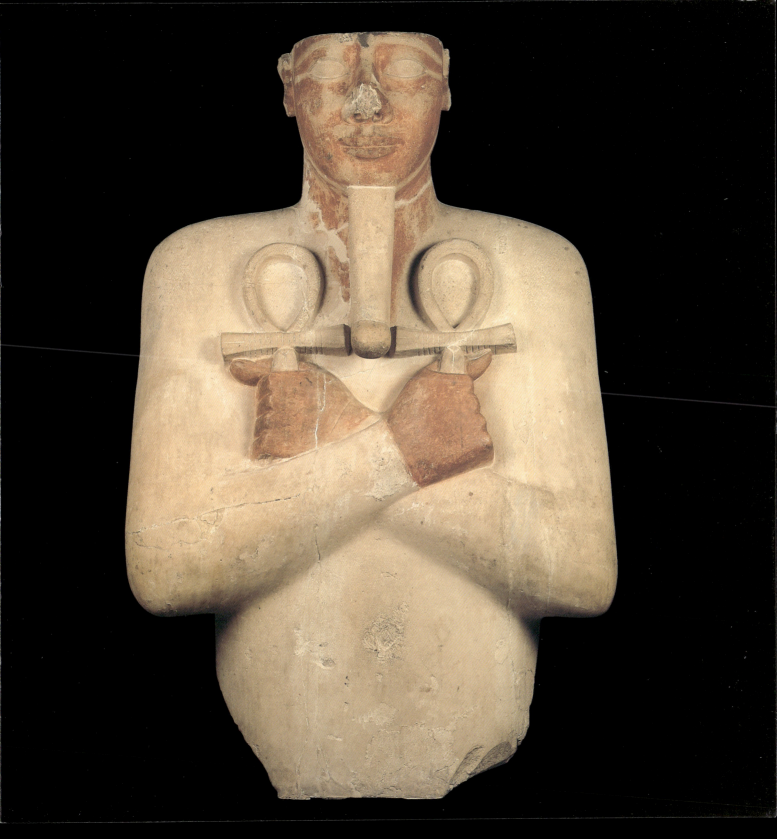

TOP OF A NICHE

Limestone, fifth to sixth century AD, Luxor Temple. H. 59.cm, Gallery I

Remains of several churches have been discovered in the Theban temples; this niche came from one that was built in Luxor Temple. It was found in the first court of the temple in 1958. The outer frame is decorated with garlands; inside it contains a shell motive and an eagle with outspread wings as part of the ornamentation. This theme was probably borrowed from ancient art, as it resembles the falcon god Horus spreading his wings over the king in a sign of protection. In addition it is also similar to the winged solar disc that was usually represented on top of the pylons of temples and on the stela lunette, signifying protection and victory.

Christianity was introduced into Egypt by St. Mark in the 1st century AD. By the 5th to 6th centuries AD, all Egyptians were Christians; the worship of the previous gods had ended and the people in practicing the new faith and demonstrating their religious beliefs, built churches in many of the temples.

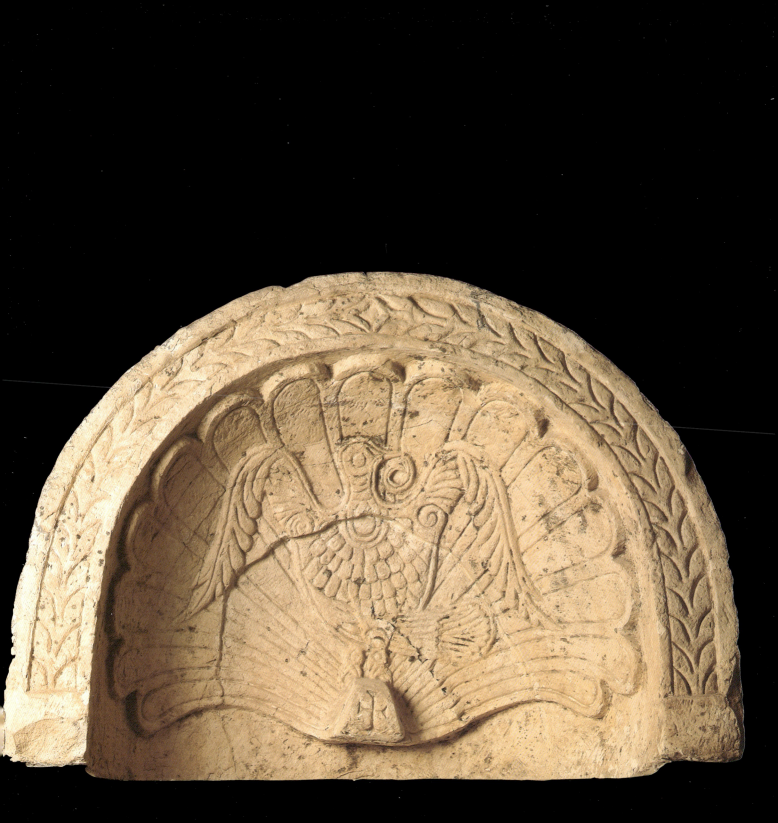

MALE FIGURE ON A BED

Sandstone, Greco-Roman period 332 BC - 641AD, Karnak, H. 47 cm, Galley I

This sandstone block was found in Karnak in 1969 outside the first pylon. It probably came from a wine press that stood there in the Greco-Roman period. It depicts a naked male figure lying on a Greek *Kline* couch with a double pillow, holding a cup probably of wine in one hand and a bunch of grapes in the other.

Male nudity was not frequent in ancient Egyptian art; it was usually limited to children and some servants.

On the other hand, the theme of wine and grapes was not unfamiliar in art in historic times. Scenes of preparing wine and beer were frequent in ancient Egypt, as the national drink, beer formed an important part of the meal. It was also a major element in the offerings to the dead and the gods. Prepared by pouring water on barley cakes and leaving the mixture to ferment in a warm place; beer was brewed in houses as well as state breweries. Sometimes ingredients like dates, honey or spices were added.

Wine, which was the most popular drink during the Greco-Roman period, was one of the main alcoholic beverages in ancient Egypt. Called *irp*, it was made from grapes and was produced from Pre-Dynastic times, as is confirmed by the presence of wine jars in tombs dating from this period. Vintage scenes have been portrayed in murals in tombs throughout the history of Egypt, and can be seen in several depictions on temple walls all over the country. Wine was used as an offering to the gods as well. Among the gods and goddesses to whom wine was offered was Hathor, who is often referred to as 'the lady of drunkenness'. While wine in daily life was merely an enjoyable drink, in myth and theology it was a symbol of blood and the power of resurrection.

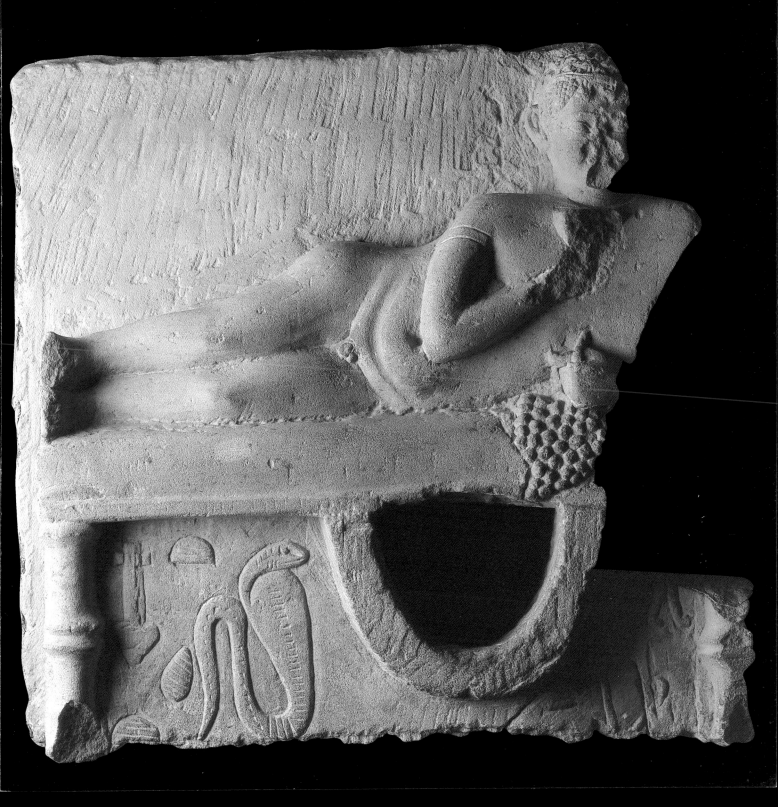

GLOSSARY OF ANCIENT EGYPTIAN WORDS

Ankh	Sign of life
Atef	Crown of the god Osiris, flanked by two feathers
Heb-sed	Jubilee festival during which the king's power and kingship were confirmed and renewed
Hedjet	White crown of Upper Egypt
Heka	A sceptre in the form of a crook, symbol of power
Irp	Wine
Ka	One of the elements of a person, representing his double or a vital force, depicted as two upraised arms
Nbty	The two ladies, Wadjet and Nekhbet, goddesses of Upper and Lower Egypt, one of the royal titles
Nekhekh	The flagellum sceptre, symbol of authority
Nemes	A royal headdress
Nw	Offering jar
Sekhem	Power
Sekhmty	Double crown of Upper and Lower Egypt.
Sema-tawy	Unification of the two lands
Seshen	Lotus
Shendyt	Royal pleated kilt.
Usekh	Broad beaded collar
Wadj	Papyrus
Was	Dog-headed sceptre, symbolizing prosperity

INDEX

Abu Simbel 28, 94

Abydos 21, 27, 96, 119

Ahmose I 21, 23, 86

Ahmose Nefertary 86

Akhenaten 27, 72, 122, 124, 126, 128

Amarna letters 50

Amen 15, 17, 21, 25, 26, 27, 28, 29, 30, 31, 32, 36, 44, 48, 50, 52, 62, 78, 80, 108, 116, 118, 120, 122, 124, 130

Amenemhat I 17, 130

Amemhat III 58, 60, 70

Amenhotep, Son of Hapu 106

Amenhotep I 120, 130

Amenhotep II 24, 25, 54, 88, 90, 96, 114

Amenhotep III 17, 19, 25, 27, 34, 36, 38, 42, 50, 72, 104, 106, 114, 122, 128

Amenhotep IV 25

Ankhesenpaamen 52

Archaic Periods 15

Aten 25, 26, 27, 52, 122, 124, 126, 128

Atef Crown 68

Avaris 19, 21, 27, 86

Ay 27, 52

Bes 50

Buhen 120, 130

Byblos 30, 42, 92

Cambyses 31

Cataract, First 54

 Fourth 23, 24, 26, 68

 Second 19, 26, 54, 120, 130

Third 120, 130

Christianity 25, 32, 132

Cobra 34, 44, 46, 48, 50, 54, 58, 64, 68, 72, 90, 104, 110, 120, 122, 128

Colossi of Memnon 50

Coptos 62

Deir al Medina 15

Deir el Bahri 13, 15, 62, 68, 80, 96, 106, 110

Dra Abu el Naga 13, 21

First Intermediate Period 15

Giza 15, 25, 88

Hathor 15, 17, 42, 70, 78, 88

Hatshepsut 23, 24, 66, 90, 116, 118, 119

Hapy 46

Heliopolis 25, 38, 46, 130

Hittite 28, 52, 92, 94

Horemheb 27, 44, 46, 124

Horus 44, 46, 56, 70, 132

Hyksos 19, 21, 27, 84, 86, 118

Isis 29, 32, 46, 50, 52, 78, 80, 100

Iwnet 38

Ka 50, 116, 130

Kadesh 24, 27, 28, 92

Kamose 21, 84, 86

Karnak 11, 23, 24, 27, 31, 32, 50, 52, 54, 64, 68, 80, 84, 88, 90, 96, 100, 104, 106, 108, 118, 122, 130, 134

Khonsu 29, 70, 78

Late Period 15, 31
Luxor Temple 36, 38, 48

Maat 72, 116
Manetho 19
Mecyrinus 15
Medinet Habu 15, 29, 110
Memphis 15, 17, 19, 23, 25, 30, 31, 32, 42, 58, 88, 90
Menes 15
Merenptah 28
Middle Kingdom 15, 19, 58, 108, 112, 122, 130
Mittani 50
Montu 15, 17, 56, 108
Montuhotep 17, 108
Mut 11, 78, 104, 110
Mutemwia 25

Neb-Re 98
New Kingdom 13, 21, 30, 31, 48, 78, 90, 96, 104, 108, 110
Nubia 23, 24, 25, 28, 30, 31, 48, 50, 54, 64, 68, 84, 88, 96, 100, 102, 108, 118, 120, 130

Old Kingdom 15, 31, 58
Old Testament 31
Osiris 27, 46, 68, 96, 110, 130, 136

Pyramid Texts 62

Second Intermediate Period 21
Sed festival 56, 72, 124, 130
Seti 27
Seti I 27, 30, 78, 96, 119
Seti II 28

Skenenra Taa 86

Sekhmet 42, 78, 98, 104

Senmut 119

Senusert I 19, 130

Senusert II 60

Senusert III 24, 54

Sinuhe 19, 122, 130

Sneferu 17

Sobek 70, 72, 76, 118

Taharqa 48

Tel al-Amarna 26, 50

Theban Triad 11, 78

Third Intermediate Period 30

Tiye 72, 110, 122

Tombs of the nobles 13, 29

Tutankhamen *9, 11, 26, 27, 52*

Tuthmosis I 23, 116, 119

Tuthmosis II 23, 80, 118

Tuthmosis III 13, 15, 23, 24, 25, 56, 62, 64, 68, 80, 88, 90, 112, 116, 118, 119

Tuthmosis IV 25, 90, 114, 122

Valley of the Kings 13, 15, 28, 29, 80, 90, 96, 100, 110

Valley of the Queens 13, 15

White Crown 50, 68, 120

Pia 76

Ptolemaic 15, 32, 52, 106

Ramsses I 27

Ramsses II 9, 28, 29, 30, 72, 92, 94, 96, 98

Ramsses III 28, 29, 100, 110, 122

Ramsses IV 28, 29

Ramsses V 29

Ramsses VI 29, 100

Ramsses VII 29

Ramsses VIII 29

Ramsses IX 29

Ramsses X 29

Ramsses XI 28, 29, 30

Yuya 72

BIBLIOGRAPHY

1. Aldred, C., *Middle Kingdom Art in Ancient Egypt*, London, 1950.
2. Aldred, C., *New Kingdom Art in Ancient Egypt during the Eighteenth Dynasty*, London, 1961.
3. Aldred, C., *Akhenaten, King of Egypt*, London, 1988.
4. Aldred, C., *Egyptian Art,* London, 1980.
5. Baines, J., and Malek, J., *Atlas of Ancient Egypt*, Oxford and N.Y., 1980.
6. Brayan, B., in *The Oxford Encyclopaedia of Ancient Egypt*, Cairo, 2001, vol. 1, p. 60-65, *s. v.* Amarna, Tell el-.
7. Capart, J. & Werbrouck, M., *Thèbes, la gloire d'un grand passé*, Bruxelles, 1925.
8. Cailliaud, F., *Recherche sur les arts et sur les métiers. Les usages des anciens peuples d'Égypte, de la Nubie et de l'Éthiopie*, Paris, 1831.
9. D'Auria, S., Lacovara, P. & Roehrig, C., *Mummies and Magic. The Funerary Arts of Ancient Egypt*, Boston, 1990.
10. David, A. R., *The Ancient Egyptians' Religious Beliefs and Practices*, London, 1982.
11. Davies, Jon, *Death, Burial & Rebirth in the Religions of Antiquity*, London, 1999.
12. Davies, N. de G., *The Tomb of Rekhmire at Thebes*, N. Y., 1943, 2 vols.
13. Eaton-Krauss, M., in *The Oxford Encyclopaedia of Ancient Egypt*, Cairo, 2001, vol. 1, p. 48-51, *s. v.* Akhenaten.
14. Erman, A., *Life in Ancient Egypt*, N. Y., 1971.
15. Faulkner, R. O., *The Ancient Egyptian Pyramid Texts*, Oxford, 1969.
16. Faulkner, R. O., *The Ancient Egyptian Coffin Texts* I-III, Warminister, 1973-80.
17. Faulkner, R. O., *The Ancient Egyptian Book of the Dead*, London, 1985.
18. Freed, R, Markowitz, Y. & D'Auria, S., *Pharaohs of the Sun Akhenaton-Nefertiti-Tutankhamen*, London, 1999.
19. Gardiner, A., *Egyptian Grammar*, Oxford, 1978.
20. Grimal, N., *A History of Ancient Egypt, translated by Ian Shaw*, Oxford, 1992.
21. Gutgesell, M., «The Military», in R., Scultz & M., Seidel (ed.), *Egypt, The World of the Pharaohs*, Cairo, 2001, p. 365-369.
22. Hart, G., *A Dictionary of Egyptian Gods and Goddesses*, London, 1986.
23. James, T., G., H., *Tutankhamun*, Cairo, 2000.
24. James, T., G., H., *Egyptian Sculpture*, British Museum, London, 1983.
25. Kessler, D., «Tanis and Thebes-The Political History of the Twenty First to Thirtieth Dynasties», in R., Scultz & M., Seidel (ed.), *Egypt, the World of the Pharaohs*, Cairo, 2001, p. 271-275.
26. Kitchen, K. A., *The Third Intermediate Period, 2nd edition*, Warminister, 1986.
27. Leahy, A. in *The Oxford Encyclopaedia of Ancient Egypt*, Cairo, 2001, vol. 3, p. 257-260, *s. v.* Sea Peoples.
28. Lesko, B., *The Great Goddesses of Egypt,* Oklahoma, 1999.

29. Moran, W., in *The Oxford Encyclopaedia of Ancient Egypt*, Cairo, 2001, vol. 1, p. 65-66, *s. v.* Amarna letters.
30. Nims, C. *Thebes of the Pharaohs*, London, 1965.
31. Petrie, F., *The Funeral Furniture of Egypt*, London, 1937.
32. Pillet, M., *Thèbes. Palais et nécropole*, Paris, 1930.
33. Polz, D., in The *Oxford Encyclopaedia of Ancient Egypt*, Cairo, 2001, p. 140, *s.v.* Assasif.
34. Polz, D., in *The Oxford Encyclopaedia of Ancient Egypt*, Cairo, 2001, p. 384-388, *s.v.* Thebes.
35. Posner, G., Sauneron, S. & Yoyotte, J., *Dictionary of Egyptian Civilization*, London, 1962.
36. Ranke, H., *Masterpieces of Egyptian Art*, London, 1951.
37. Ranke, H., *The Art of Ancient Egypt*, Vienna, 1936.
38. Ray, J., in *The Oxford Encyclopaedia of Ancient Egypt*, Cairo, 2001, vol. 2, p. 267-271, *s. v.* Late Period.
39. Romer, J., *The Valley of the Kings*, London, 1981.
40. Schlogl, H., in *The Oxford Encyclopaedia of Ancient Egypt*, Cairo, 2001, vol. 1, p. 156-158, *s. v.* Aten.
41. Shaw, I. & Nicholson, P., *British Museum Dictionary of Ancient Egypt,* Cairo, 1995.
42. Strouhal, E., *Life in Ancient Egypt*, Cambridge and Norman, 1992.
43. Strudwick, N. & H., *A Guide to Tombs and Temples of Ancient Luxor. Thebes in Egypt*, London, 1999.
44. Taylor, J., *Death and the Afterlife in Ancient Egypt*, London, 2001.
45. Vandier, J., *La religion Égyptienne*, Paris, 1949.
46. Vogel Sang-Eastwood, G., *Pharaonic Egyptian Clothing*, Leiden & N.Y., 1993.
47. Weeks, K., in *The Oxford Encyclopaedia of Ancient Egypt*, Cairo, 2001, p. 381-384, *s.v.* Theban Necropolis.
48. Winlock, H. E., *Models of Daily Life in Ancient Egypt*, N.Y., 1955.

Abeer el Shahawy, M.A., is an Egyptian Egyptologist, who obtained her B.A and M.A. from Helwan University, Cairo. She is the author of several books including her most recent *"The Funeral Procession: A Bridge to the Realm of the Hereafter"* and *"The Egyptian Museum: a Walk through the Alleys of Ancient Egypt"*.

In this fine book, the writer has contributed detailed and informative descriptions about each of the selected artefacts. Not only that, but her comprehensive and fascinating explanations take us back in time to Thebes in her days of glory.

Writer, photographer and publisher Farid Atiya is the author of many books on the Red Sea, Sinai and the monuments of Egypt, including the acclaimed *"The Red Sea in Egypt, I and II"*, *"The Best Diving Sites in the Red Sea"*, *"Red Sea Panorama"*, *"The Brother Islands"*, *"Cheops's Solar Boat"*, *"The Silent Desert, I Bahariya and Farafra"* and *"Pyramids of the Fourth Dynasty"*.